SOUTHEND AIRPORT

THROUGH TIME

Peter C. Brown

AMBERLEY PUBLISHING

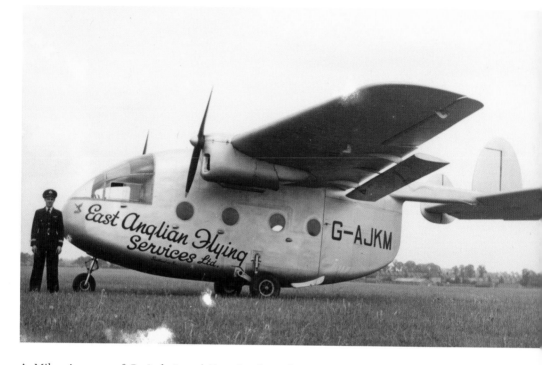

A Miles Aerovan of R. Jack Jones' East Anglian Flying Services at Southend Airport. (*J&C McCu Collection*)

First published 2012

Amberley Publishing
The Hill, Stroud
Gloucestershire, GL5 4EP

www.amberley-books.com

Copyright © Peter C. Brown , 2012

The right of Peter Brown to be identified as the
Author of this work has been asserted in accordance
with the Copyrights, Designs and Patents Act 1988.

ISBN 978 1 4456 1012 2

British Library Cataloguing in Publication Data.
A catalogue record for this book is available from
the British Library.

Typeset in 9.5pt on 12pt Celeste.
Typesetting by Amberley Publishing.
Printed in the UK.

Introduction

London Southend Airport is an international airport in the district of Rochford, around 2 miles north of Southend-on-Sea, Essex, and is one of the six main airports serving London. Like many airports it began life as a landing strip for pleasure flying; it was the largest flying ground in Essex, and was established by the Royal Flying Corps during the First World War as part of the air defence network of London. After the war it was largely returned to farmland although flying clubs and pilot training continued to operate. During the Second World War it played a vital role as a forward fighter station under the command of RAF Hornchurch.

Even before the end of the war, its potential was recognised as a gateway to Europe for passengers and cargo, and in 1947 was a seed bed for East Anglian Flying Services, Aviation Traders and the Municipal Flying School. Its potential was realised in the 1950s when two runways were laid – the 06/24 and 15/33 – and it subsequently became one of the busiest airports in the country during the 1960s. It was home to some of the most innovative aircraft designs of the time, including the Carvair.

An extension to the south-westerly end of the runway by 300 metres became operational on 8 March 2012, making its total length 1,905 metres, and technically allows the airport to accommodate aircraft up to the size of a Boeing 757 for passenger flights.

With an extensive range of hangars, it is one of few airports that can carry out every aspect of aircraft maintenance, including airframe maintenance checks, aircraft repainting, interior repair and refurbishment, and has an Engineering Training School.

Acknowledgments

Many people have kindly assisted me with this book, by sending me images (a great many of which have not previously been published), or supplying information, arranging meetings, and offering encouragement and support. My thanks go to:

Jackie Bale, Serge Bonge, Rob Bowater, Trevor Buckland, Keith D Burton, Chris Chennell, Ron Circus, Barry Cole, Dan Davison, David Ford, Joe Futuko, Calum Glazier, Kevin Haigh, Trevor Hall, Terry Joyce, Ian Longshaw, Graham Mee, Felix P. Ormerod, Colin F Pickett, Ian Press, Nick Skinner, Maurice Smithson, Richard Vandervord, Geoff Whitmore.

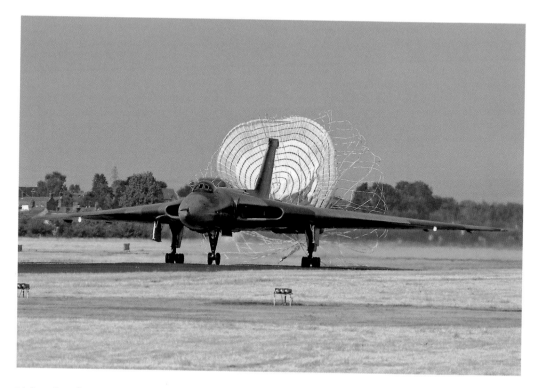

Vulcan bomber G-VJET at Southend Airport. (*Keith D. Burton*)

1909–1914

The area that would become the vibrant airport it is today has a history that stretches back to the Middle Bronze Age onwards; trial trenching at Westbarrow Hall Farm reported in 2009 revealed artefacts and evidence of considerable activity during that age, and of a possibility of continuous settlement from prehistoric times.

Prior to becoming an airfield, the area was farmland stretching between Westbarrow Hall and the Great Eastern Railway line at Warners Bridge two miles north of Southend. It was bordered to the south by Eastwoodbury Lane; relatively open country lay for about three-quarters of a mile to the north as far as St Andrew's church, Rochford. To the west a tributary of the River Roach and hedges ran northwards along the west side close to St Lawrence and All Saints church, and the eastern border stopped short of the Southend Victoria to Liverpool Street Railway Line.

Initially marked during the day by a white strip, the landing ground later had the usual luxury of a landing circle added. The south and west sides also had 12-foot-high poles with telephone wires strung between them, which would give the aerodrome great advantage in having direct communication with London at the outbreak of the First World War.

1914–1918

The Royal Flying Corps had been established on 13 April 1912 as a result of the growing potential of aircraft as a cost-effective method of reconnaissance and artillery observation, and the War Office listed Southend as a potential landing ground in 1914 and subsequently acquired it for training purposes until May 1915, when the Royal Naval Air Service took over the airfield. They set up camp in the south-west corner, near to the church, where a copse of trees existed; the airfield had been designated as a night fighter station. However, following the Zeppelin bombardment of London on 31 May, the site was quickly occupied by 'A' Flight of 37 (Home Defence) Squadron, RFC, with their Royal Aircraft Factory B.E.2 and B.E.12 aircraft (the B.E. standing for 'Bleriot Experimental'). They had been charged with the eastern aerial defence of London. 'B' Flight was stationed at Stow Maries and 'C' Flight at Goldhanger. The accommodation on the landing field consisted of wooden huts and tents. The co-ordination of the flights was from their headquarters at 'The Grange', Woodham Mortimer.

The last RNAS action took place on 26 April 1916, and on 4 June, the site was handed back to the RFC, becoming 'RFC Rochford', and retaining its night fighter station designation.

The site boundaries were squared off to encompass an area of 168 acres, which at the time was the largest airfield in Essex. A building programme was started with anticipated completion date of November 1918. Captain Cecil A. Lewis, who commanded a flight of 61 Squadron at Rochford, later wrote in his account of his time as an aviator in the First World War, *Sagittarius Rising,* that the airfield had the reputation for being the most comfortable billet in the RAF, recalling it as 'a magnificent aerodrome almost a mile square in extent.'

However, six months on most of the ground staff still occupied billets in Rochford, and the aircrews remained at the *Westcliff Hotel* in Clifftown Parade, Southend, because the on-site accommodation for them hadn't been completed. The major problem with that, of course, was that in the event of an alert, the duty crews would have to be driven from the hotel in Southend to the aerodrome before anything else.

Several squadrons used the airfield for varying durations; 198 Depot Squadron was formed at Rochford in February 1917, and apart from a Vickers F.B.12C, and Royal Aircraft Factory B.E.2 and B.E.12 aeroplanes, was also equipped with Avro 504 trainers (mainly for British Expeditionary pilots who were transferring to Sopwith Pups or 1½ Strutters and who were required to learn rotary-engine handling techniques). On 2 August 1917 61 Squadron RFC (and later 141 Squadron, which was formed from a section of it) was formed at Rochford as a Home Defence unit, initially equipped with Sopwith Pups. Wing Commander Giles Turberville, who served as a Lieutenant with the squadron, went on become the Public Relations Officer for British Air Ferries at Rochford after the Second World War. The squadron flew many sorties, chalking up several successes in deterring enemy raids by Zeppelins and the large Gotha bombers, both before and after the RFC and RNAS were amalgamated to form the Royal Air Force on 1 April 1918.

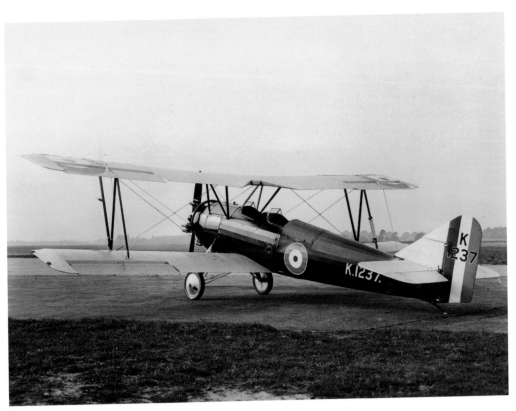

The Avro Tutor Type 621 (K-1237) was a simple but rugged two-seat British radial-engined biplane initial trainer that was used by the Royal Air Force from the interwar period. (*Author's Collection*)

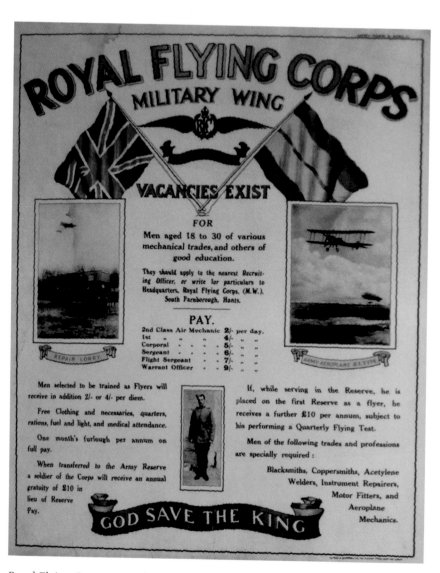

Royal Flying Corps poster. (*Creative Commons Licence*)

Between the Wars

After the Armistice was signed, the running-down of the unit activities began. 61 Squadron remained at Rochford until the Royal Air Force derequisitioned the aerodrome, whereupon the squadron was disbanded and re-formed at Hemswell, Lincolnshire.

On 10 May 1919, Messrs Thompson & Nicholson began operating two Avro 504K three-seaters of the Navarro Aviation Company. Pleasure flying had begun and the aerodrome, because of its size, also played host to regular air pageants.

However, aviation lessened due to a gradual slump in trade, and the station was closed in 1920 and a large part of the site was returned to farmland. This period could well have been the end of the airport but for the vision held by one Southend Councillor, G. E. Weber, and the keenness of those associated with him. He saw a future where the town would need a municipal airport to ensure its prosperity. The old First World War runways still lay beneath the crops and he succeeded in persuading his fellow councillors that the airfield could be revived.

In 1933 Southend-on-Sea Corporation bought the site for the building of a permanent airfield and it became the first municipal-owned aerodrome in the country.

The surface of the area then measured about 1,200 by 1,000 yards; the landing area was confined to a space roughly 450 yards square at the northern end.

The Southend Flying Club (SFC) had moved in from their landing strip in Ashingdon; Crilly Airways and Southend on Sea Flying Services were already in residence and enjoying a busy time giving flying lessons, and by the summer of 1934 SFC were operating an hourly service between Southend and Rochester.

The big attraction in the area at the time were the Henri Mignet-designed Flying Fleas (tiny single-seat aircraft around 11 feet long and invariably powered by a two-stroke engine); hundreds of spectators flocked to grounds at Ashingdon, Rochford and the present Southend airport site for the thrill of watching a handful of enthusiasts risk their necks for a few seconds' flying. Four of the Flea enthusiasts were well-known figures in Southend. Among them were Bernard Collins, MBE,

Southend's airport commandant (and later with Channel Airways), Chris Storey, proprietor of the Alexandra Street garage that bore his name, and Mr Alick Pearce, by day an assistant sales manager with the Southend Motor and Aero Company, and by night licensee of the George and Dragon on Foulness, and finally Captain Claud Oscroft, a senior captain with Swissair.

Flea flying was highly dangerous - a number of pilots were killed. The Airport Commandant's first log book gives some idea of the hazards. One entry reads: 'Approached Dorking at 3,000 feet, machine dived out of control to 500 feet. Floor gave way. Resolved never to fly Flea again.'

On 18 September 1935, the landing area having been completed, and £25,000 having been spent on a combined clubhouse and hangar, a ceremony took place for the official opening of the aerodrome by the Mayor, Mr Allen T. Edwards, and was attended by several hundred people. The *Southend Standard* printed that it was considered to be 'perhaps the most significant and vivid page in the history of modern Southend'. It was operated by the Southend Flying Club (which was busy with air taxi work, many trips being made to Gravesend, Maidstone and Loughton), and Southend-on-Sea Flying Services in conjunction with Short Brothers. More than thirty aeroplanes from all parts of Britain had arrived for the occasion, and guests included Sir Philip Sassoon, then the Under Secretary of State for Air, former air ace F. Garland, and the aviator Charles Scott (who had won the MacRobertson (London to Melbourne) Air Race in 1934.

Plans had also been drawn up to erect a separate administrative block in the near future. It was hoped at the time that a railway station or a halt on the LNER line would be erected to serve the aerodrome.

During 1936 the Royal Air Force Volunteer Reserve formed at Southend along with a dozen other airfields, working alongside the Civil Air Guard, and by 1937 was a formidable presence. During the summer, 602 (City of Glasgow) Squadron of the Auxiliary Air Force arrived with their Hawker Hinds, and were joined later by 607 (County of Durham) Squadron (AAF).

In May 1936, Bernard Collins, at the age of 20, set the British long-distance flying record for Fleas - 87 miles from Heston to Melton Mowbray, an astonishing achievement. He knew nothing until it was announced on the BBC News while he was sitting at home that evening.

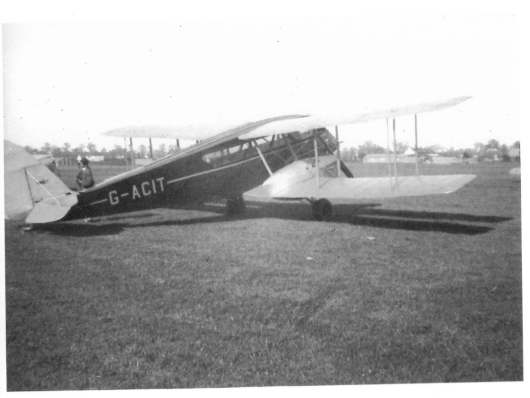

de Havilland Dragon Rapide (G-ACIT), once held by Southend Museum and now at Wroughton. (*Nick Skinner*)

1939–1945

During August 1939 the Air Ministry requisitioned all commercial airfields. The flying club and some private aircraft at Southend were put into storage in warehouses and furniture depositories in Southend and Westcliff (most of them were eventually broken up and dumped in 1941–42). The Reserve Flying School moved out and the airfield became known as 'RAF' Rochford and was placed in No. 11 Group of Fighter Command as a satellite fighter station for RAF Hornchurch.

Fifty pillboxes (about twenty of which still survive) were placed around the local countryside to protect the airfield and the Air Ministry Experimental Station Type 1 radar station that had been secretly built on the edge of Canewdon in 1937 and which formed part of the Chain Home (Early Warning) Radar system that operated (initially) on the south and east coasts of Britain.

On the airfield, the Battle Headquarters and control room were sited between two aircraft pens on the eastern side of the airfield, backing onto Eastwoodbury Lane. Just to the east of these were two large Bellman Hangars, the Gas Defence Centre, fire crew huts, oil and petrol stores, water tanks and barracks. Spread among all these were eleven Stanton shelters which provided bolt-holes during air raids, and ground defences comprising three pillboxes, four Hispano 20 mm machine gun posts and an anti-aircraft emplacement.

Along the northern perimeter another aircraft pen sat close to a blister hangar, and to the north of these were the fusing and detonator sheds and bomb stores (which all backed on to the Rochford Golf course), Nissen huts, the cine camera room and gun workshops, a Stanton shelter, the latrines and the drying room. A picket post, hangar, and brick shelters were on the western end of the airfield close to the railway line.

On the southern side were two aircraft pens, blister hangars, flight offices, barracks, latrines and drying rooms, two pillboxes, a 12,000-gallon aviation petrol store, an anti-aircraft gun emplacement, and shelters.

Three Pickett Hamilton forts were also sited in the north-east, north-west, and south-west of the landing ground. Unlike pillboxes, which would have presented a constant danger to aircraft on the landing areas, especially at night time, these were pre-cast concrete sleeves inside which

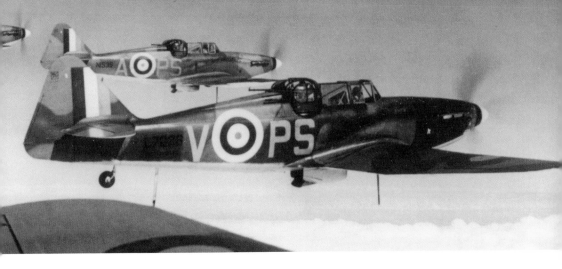

Boulton-Paul Defiants of 264 Squadron, based at Southend. L-7026 was shot down over Thanet during the Battle of Britain, killing Pilot Officers P. L. Kenner (pilot) and C. E. Johnson (air gunner). (*Author's Collection*)

a turret could be raised or lowered when required by means of a hydraulic pump, and the gun crew inside would be in action within a few minutes. It was manned by two or three men, and was not the best environment in which to spend any length of time as it frequently filled with rain water.

54 (F) Squadron was the first squadron to arrive from Hornchurch with its Mark I Spitfires, followed in October by 600 (Auxiliary Air Force) Squadron with Bristol Blenheims.

On 18 June 1940, Rochford entered the record books when Flight Lieutenant Adolph 'Sailor' Malan of 74 Squadron became the first single-seat pilot to shoot down two Heinkel bombers at night.

Following the Battle of Britain, the aerodrome became a fighter station in its own right and was known as 'RAF Southend' from 28 October 1940, although fighter control remained with Hornchurch until May 1941, when it was transferred for a period of time to North Weald.

As Fighter Command moved towards a more offensive role, Southend became home to many RAF squadrons: 19, 41, 54, 64, 74, 127, 137, 222, 234, 264, 317, 603, 611 and 616, as well as 'foreign' squadron: 121 (American 'Eagle'), 350 (Belgian), 402 (Canadian), 403 (Canadian 'Wolf') and 453 (Royal Australian Air Force). They flew the Supermarine Spitfire, Hawker Hurricane, Boulton-Paul Defiant (the 'turret fighter' without any forward-firing gun), Westland Whirlwind (the twin-engine, cannon-armed heavy fighter), and Bristol Blenheim (the twin-engine light bomber with a powered gun turret). It was not uncommon for two or even three squadrons to be operational at Southend at one time. The airfield also became a regular target for the Luftwaffe, and was bombed and strafed, along with Southend Pier, the high street and the areas in close proximity, on several occasions.

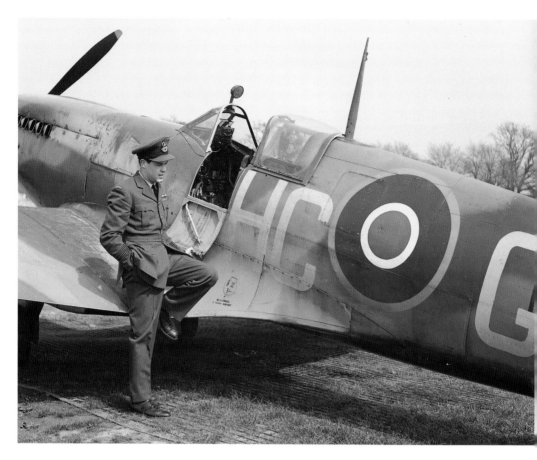

Flight Lieutenant Hugh Godefroy, DSO, DFC with his Spitfire (PL-29352) of 403 (RCAF) Squadron at RAF Rochford in 1942. (*Joe Futuko*)

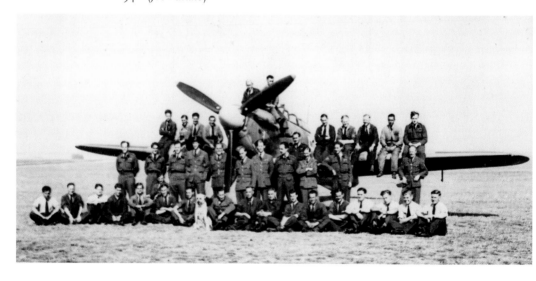

A gathering of the pilots of 137 Squadron, which was stationed at Southend during 1942. (*Rob Bowater*)

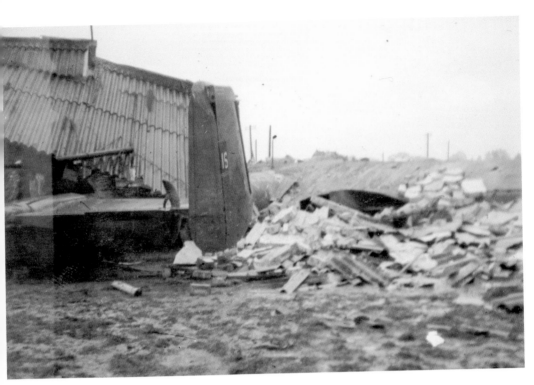

The Dornier Do-217E that was shot down by a gunner of the Anti-aircraft Section (2830 Squadron) of the RAF Regiment but crashed into the Dispersal Hut of 350 (Belgian) Squadron at Rochford on 26 October 1942, killing one man and seriously injuring two more. Three of the enemy crew were also killed. (*Serge Bonge*)

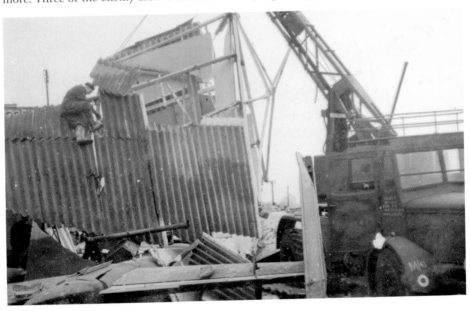

Another view of the 350 (Belgian) Squadron Dispersal Hut following the crash in October 1942. (*Serge Bonge*)

1946–1956

In 1946 the airfield was de-requisitioned and a Civil Aviation Authority (CAA) License was issued to Southend Corporation on 31 December 1946, with Bernard F. Collins as manager and Alan Fincher of the town's Engineers Department as assistant manager. Half the site (the western boundary) had been reserved for a Gliding School for Air Training Corps Cadets, while the other half operated club and commercial aircraft. The Belfairs Model Aero Club had set up in a Nissen hut on the ATC's grounds, and held a number of model aircraft contests.

On 1 January 1947 civil flying resumed once again, and on 5 January East Anglian Flying Services (EAFS) Ltd was started by Squadron Leader R. Jack Jones, who realised the potential of the airfield for easy access to the Continent and operated from one of the wartime huts with an Airspeed Courier, Puss Moth, Auster, and a Miles Aerovan. He operated a scheduled feeder service between Southend and Rochester, and while waiting for his licence to operate scheduled flights to Ostend, offered chartered hotel-inclusive flights to that destination, backing up his income with services as an air taxi, short-haulage, and air photography until his licence was finally granted.

In February the Municipal Flying School opened, and grew rapidly to become the country's premier training establishment.

Despite flying activities having gone on for some time, the airport was officially opened by Mr Lindgren at the invitation of Alderman W. Miles on 9 August 1947. Air races and a big display followed, with the intention of making the International Rally and Races an annual event. The enclosure was open to the public free of charge; there was already a restaurant, limited residential accommodation and a swimming pool; and tennis courts were to be constructed. Plans were also in hand to make the airport the centre of aviation in the area, and would include a general sports centre.

Passenger handling facilities were poor at the time, but plans had been drawn up for the provision of buildings for administration and to accommodate Customs, Immigration and offices for other charter companies, and perhaps scheduled airlines. The airfield had a 1,500-

yard take-off run in each direction and full night-flying equipment was going in.

In 1948, Customs facilities were set up to cover the new services to Ostend and the Channel Islands by East Anglian Flying Services with their enlarged fleet of five ex-RAF De Havilland Dragon Rapides.

Aviation Traders Ltd (ATL), which was established by Freddie Laker to trade in war-surplus aircraft and spares at Bovington, Hertfordshire, moved to Southend and initially specialised in converting Handley Page Halifax bombers into freighters. At the end of the Berlin Airlift, most of the converted aircraft he had supplied to various independent airlines were scrapped at Southend. His efforts then went on Aviation Traders (Engineering) Ltd, which he established in 1949 with Jack Wiseman in charge.

In early 1949, Mr Bernard F. Collins, who had been the Airport Manager since November 1946, realised that in order to offer 'all weather' capability at the airport, they would need a 'talk-down' radar system. The GCA (Ground Controlled Approach) radar that had been used during the Berlin Airlift would fit the bill, but it was hugely expensive (estimated at around £50,000) and only the military and large international airports could really afford it. So he arranged a meeting with Eric Cole (EKCO) to discuss a talk-down system and the issue of its high price. Eric tasked his Chief Engineer, Tony Martin, and his team to develop a system that was as good as the GCA, but at a fraction of the cost, and it was found that the ARI-5820 (the Hawker Hunter Radar Ranging System) could be adapted for the purpose.

Silver City, which had leased more Bristol Freighters during the Berlin Airlift, was the last company based at Southend still operating twin-engine civil aircraft at the time the relief operation was scaled down in February 1949. Later that year the company established a sister company in France, and in 1954 re-located to Lydd (the first airport to be built in the UK after the Second World War).

In the early fifties, the airfield was still coming out of a depressed period following the end of the war, mostly only having light aircraft and club flying in residence. The runway was grass, illuminated at night by the placing and igniting of numerous 'Gooseneck' (paraffin) lamps. The landing 'T' (Runway in Use Director) was also Gooseneck illuminated, hence the name 'Flare Path'.

By June 1950, the radar tests were complete and the resulting system, which gave a range of 16 miles, gained approval and certification by the CAA in December 1951, thus allowing the system to be used operationally, and it was demonstrated to the press in January 1952.

In 1951 construction began of the new terminal building; it would house a coffee shop, check-in desks, duty free shopping and departure lounge, a newsagent, a Hertz car hire desk and a taxi hire desk.

On 7 February 1952, BKS (James Barnby, Thomas (Mike) Keegan and Cyril Stevens) Air Transport and Engineering began flying an ex-Crewsair Douglas DC-3 on chartered flights from Southend Airport. They operated mainly on cargo services with converted ex-RAF DC-3s and steadily increased their fleet to include Avro Ansons, Airspeed Consuls and Ambassadors, Vickers Vikings, Airspeed and the Britannia 100 series. Two more DC-3s (ex-RAF) joined the fleet in 1953 and by the end of the season they were operating five DC-3s, by which time the company was operating two services a week from Southend to Corsica for Horizon Holidays. Maintenance of the fleet was kept to a high standard by their sister company, BKS Engineering, which had been formed at Southend in January 1952.

In 1953, local flying hero Ladislav 'Ladi' Marmol set up Marmol Aviation, and Executive Flying Services began operating.

The Southend Unit (Leigh-on-Sea) was Region 12 of the Women's Junior Air Corps, a uniformed youth organisation aimed at girls of secondary school age and upwards. The WJAC had their own Fairchild Argus, a four-seater aircraft called *Grey Dove* (G-AIYO), in which girls could fly for 7s 6d. On some weekends over a hundred girls could fly, depending on weather conditions. Both the WJAC and the ATC (Air Training Corps) met weekly at Southend Airport in what was not much more than an old tin hut, where they learned Morse code, aircraft recognition and marching drills.

The Southend Unit was visited by the former Air Transport Auxiliary pilot Miss Freydis Leaf, who would take three girls up and around the airport perimeter, and back. The cadet who sat next to her took over the controls for a period of time, and each girl took their turn in flying the aircraft.

Dan Air Services was founded at Southend in June 1953 by shipping agency Davis & Newman Ltd with a single war surplus Douglas DC3 Dakota for a six-month contract to operate a series of charter flights between Southend and West Berlin's Tempelhof Airport. The company re-located in 1955.

Southend was selected to host the 1953 National Air Race which was held on 20 June, an event that attracted thousands of spectators.

In 1954, Southend's first Air Traffic Control tower was erected on the top of the Terminal building, and incorporated the Ekco-developed radar system (which was dubbed 'the poor man's GCA' – it is believed to have eventually cost £4,000). The finished design was a structure which has

been likened to a periscope in a submarine in that the operator stood at a console and was able to follow the aircraft by literally rotating the entire radar-receiving unit by turning it on its axis. It was about 3 feet square, the front of which had a 5-inch-diameter 'A' scope and an illuminated compass above together with an illuminated series of lights, which told the approach controller if the aircraft was 'on track', or off to the left or right. It proved to be a very long-lasting and reliable system, remaining in use at Southend until about 1982.

The start of real development at the airport got under way when Freddie Laker's Channel Air Bridge (the sister airline of Air Charter) started flights for passengers and cars to France in their Bristol Mk 31 Freighters.

In 1955, EAFS started a service to Rotterdam and during Easter a regular service was launched to Calais, followed by Ostend, Rotterdam, Guernsey and Paris. Channel Air Bridge also started flights to Ostend, and BKS launched their service to Leeds and Belfast. The Belgian airline Sabena also began flights to the Netherlands with Bristol 170 Freighters.

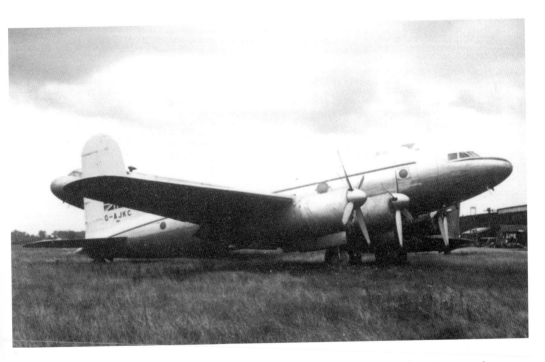

Avro 688 Tudor Freighter 3 (G-AJKC) of Aviation Traders at Southend on 6 September 1954. (*Author's Collection*)

Sylvia Corneby (the author's mother), then 16 years old, with other members of the Women's Junior Air Corps at Southend in a publicity photo taken in 1953. (*Authors Collection*)

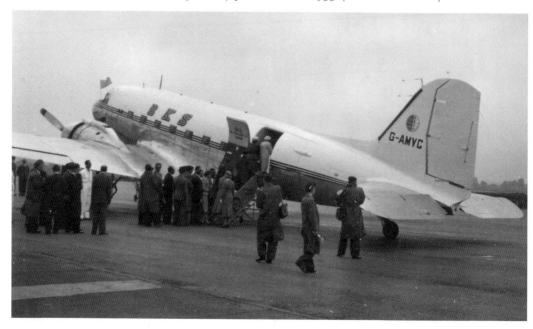

Douglas DC-3 Dakota (G-AMVC) of BKS on 4 June 1956. It crashed on a flight from Leeds Bradford International Airport to Carlisle on 17 October 1961. (*Author's Collection*)

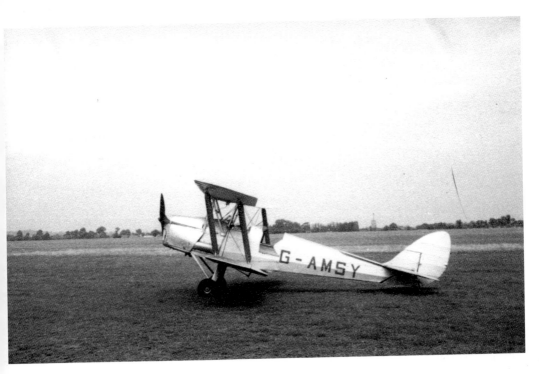

De Havilland DH82A Tiger Moth (G-AMSY). It crashed and was damaged beyond repair at Southend on 6 November 1955. (*Author's Collection*)

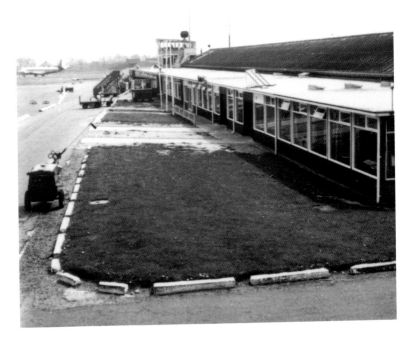

The old terminal buildings and original ATC tower in the late 1950s. (*Graham Mee*)

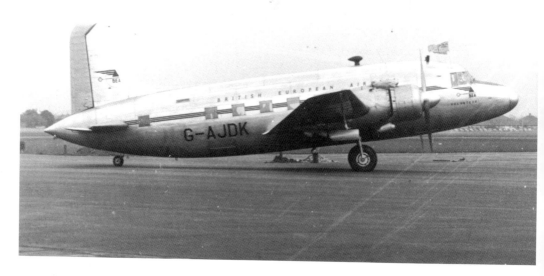

This BEA Vickers Viking Type 610 (G-AJDK) crashed and was destroyed in Turkey in November 1956. (*Author's Collection*)

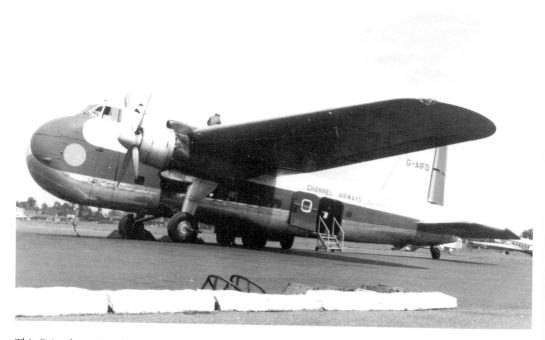

This Bristol 170 Freighter (G-AIFO) was operated by Channel Airways from 1957 and withdrawn from use in 1966. (*Authors Collection*)

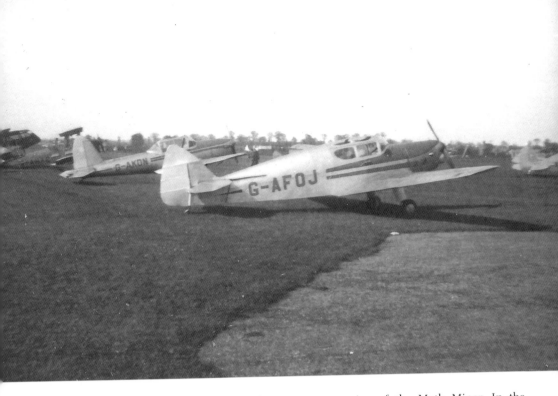

A Minor Coupe (G-AFOJ); this was the less common version of the Moth Minor. In the background is the Canadian-built Chipmunk (G-AKDN) that went on to win the King's Cup at Southend on 20 June 1953. (*Nick Skinner*)

1956–1970

Between 1955 and 1956 the two runways, 06/24 (Main) Runway and 15/33 (Secondary) Runway, were laid using the method of soil stabilisation: a process of blending the soil with a chemical admixture and cement to reduce its plasticity, compress it, and make it resilient to frost.

ATEL (Aviation Traders Engineering Limited), founded by Freddie Laker, purchased all the 252 Percival Prentice trainers from the RAF that had been parked in the centre of the airfield since coming to the end of their service life. Twenty-one of these were civilianised and the rest scrapped at Stansted.

In 1957, EAFS added two Bristol B170 Freighters to their fleet. During that year a number of the Southend-based airlines were amalgamated; Airwork Services Ltd, Transair, and Hunting-Clan Airways became British United Airways. At this time, ATEL was starting work on the conversion of a Douglas DC-4 into a carrier of passengers and cars.

Aviation Traders also started design and construction work on the ATL-90 'Accountant', a twin-engined, twenty-eight-seater, turboprop airliner which was to replace the DC-3. Flight testing began on 9 July 1957.

In 1958, East Anglian Flying Services launched a service to Johannesburg, and added two Vickers Vikings to their fleet. These were put on to the high density routes to the Continent and Channel Islands while their Doves were used on the feeder services to Southend. Christmas 1958 was a disaster for airlines. Heavy fog engulfed England and all airports were closed down with the exception of Southend, which handled over fifty extra arrivals until lack of space closed it down, just before the fog descended on the area.

Freddie Laker sold ATL and Air Charter to Airwork in 1958; the deal came into effect from 1 January 1959, when they started the 'No Passport' day trips to France.

The 1960s were times of significant change. Channel Airways purchased its first four-engined airliners – DC-4 Skymasters. Silver City and Channel Air Bridge became BUAF (British United Air Ferries). The Fuel Farm Storage was increased to six 18,000-gallon tanks; two Merryweather Fire Tenders replaced the old Crossley Tender, and a

Land Rover and Powder Trailer were also purchased. High and Low-intensity electric runway lighting was installed.

Anthony Cusworth (the nephew of the Earl of Buckinghamshire) became the airport commandant.

'I've got an idea'

Air Bridge's specification for the ideal second-generation ferry aircraft, drawn up four years previously, called for: (1) low first cost; (2) simplicity of servicing and overhaul; (3) about 70 feet of hold space (accommodation for five cars); (4) twenty-five passengers; (5) a payload of some eight tons; (6) faster (200 m.p.h.) and quieter than the Bristol; and (7) space for a toilet and galley. The story goes, and it is a true story, that Freddie Laker, managing director of the Air Bridge's parent company, said one day: 'I've got an idea.'

ATL produced the Carvair (Car-via-Air) conversions (coded 'Yankee B') from Douglas Dakotas DC-4 and DC-7 aircraft. These car ferries had a hinged nose-door through which up to five cars could be scissor-lifted (the lift was also designed by ATL) one at a time into the cargo hold. The flight deck was above this and seating for twenty-five passengers was in the remaining rear of the fuselage.

The first Carvair was extensively tested; water tanks were loaded as ballast at strategic places through the fuselage to simulate the weight of twenty-five passengers and five medium sized cars, and the aircraft commenced take-off runs that were deliberately aborted within the runway's length. More water ballast was added and the procedure was repeated many more times until sufficient information and adjustments had been recorded. Yankee B finally took off and performed a circuit, looking magnificent with its high cockpit. Over the following days many more circuits and bumps were carried out, and the ballast was increased for tolerance tests.

Twenty-one conversions were carried out, and the first three Carvairs were delivered to Channel Air Bridge in time for the new long-haul services to begin in April 1962. Within a short time, these huge aircraft were a common sight over the skies of Southend.

The old control tower was replaced in about 1961. The normal staffing roster consisted of three people in the tower and a telephonist downstairs in 'flight planning'. They worked a 'split-pattern' shift of 8 a.m. to 1 p.m. and 6 p.m. to 11 p.m. followed by time off. The next shift was 1 p.m. to 6 p.m. and 11 p.m. to 8 a.m. followed by time off. The only staff who worked a normal day were the radar technicians who also had an office in the tower. The numbers were sometimes added to during peak traffic periods.

CCTV had also been introduced to allow the controllers to see the end of runway 06 following the building of the Aviation Traders end hangar.

East Anglian Flying Service became Channel Airways on 29 October 1961, one of the UK's five leading independent airlines of the decade. The airport provided work for over 2,000 people and was one of Southend's biggest industries. Around 500,000 passengers a year were using the terminal and the airport was becoming increasingly important for freight traffic with the Bristol Freighters and the Carvair.

On 2 October 1962, Channel Air Bridge received Carvair G-ARSD from Stansted and on the same day it took off on the inaugural flight to Geneva. Channel Air Bridge merged with Silver City Airways to become British United Air Ferries (BUAF) with an official launch on 1 January 1963. The newly formed airline was a wholly owned subsidiary of Air Holdings. This ownership structure made BUAF a sister airline of British United Airways (BUA) and it operated scheduled and non-scheduled vehicle ferry, passenger and freight services, and from Southend flew regularly to the Channel Islands, Ostend, Rotterdam, Strasbourg, Bremen, Basle, Calais and Geneva. It was at the time Britain's biggest independent airline and the country's leading independent scheduled operator.

In 1963, Channel Airways acquired Tradair, and also purchased a fleet of fifty-two-seat luxury coaches (which comprised of AEC Reliance and Duple-bodied Fords) for passenger holiday transport and transfers under the name of Channel Coachways. They operated from the front of the terminal building, a large fuel store being situated close to the entrance of the south side. The company was later taken over by Ray Jennings and Les Caten.

In 1963, a scene from the James Bond film *Goldfinger* (released in 1964) saw Sean Connery and his famous Aston Martin DB5 driving into the airport, having tracked (in the story) Auric Goldfinger's Rolls-Royce, and is seen being loaded into, and then transported by a Carvair of British United Air Ferries (en route to Switzerland). The day's shooting accounted for about one minute's running time in the film.

The Rochford Hundred Flying Group was founded at Southend Airport in 1964 following the closure of the Municipal Flying School, which since 1947 had produced more than 400 pilots.

By 1967, Southend had over 700,000 passengers moving through the terminal and it became the third-busiest airport in terms of passengers handled until the end of the 1970s. At that time there could be up to twenty-two return flights to the Channel Isles alone *per day*.

In 1967, BUAF changed its title to BAF (British Air Ferries) with a change in the directorship.

Channel Airways celebrated its twenty-first birthday and bought four Ford Anglias painted gold to offer as prizes for their staff in a competition.

BKS introduced the Viscount 800 into its fleet in 1968, bringing into sight the end for the Hawker-Siddeley HS748 aircraft. Subsequently, the Britannia 102s were replaced by Trident 1Es.

The airport open day which took place on 24 March 1968 drew in excess of 50,000 spectators; the car parks were full and eventually the police had to turn the traffic back at Kent Elms Corner.

It all started to go wrong in the international market when the RORO (Roll-on, roll-off) ferries (which had replaced the 'passenger-only' and 'craned' cargo ferries and had been operating since the early 1950s) started undercutting the air ferry services, and even the versatility of the mighty Carvair couldn't stem the tide.

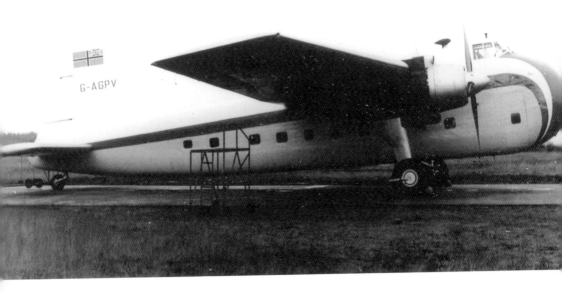

A Bristol 170 (G-AGPV) at Southend Airport. (*Author's Collection*)

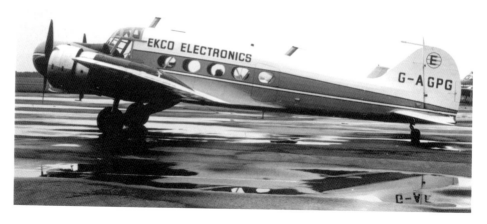

This Avro Anson C19 (G-AGPG), built in 1945, was the second Anson bought by Ekco in October 1967 and had a nose conversion in order to accommodate the 30-inch-diameter scanner dish required for the E390/564 weather radar system then under development for Concorde. (*Author's Collection*)

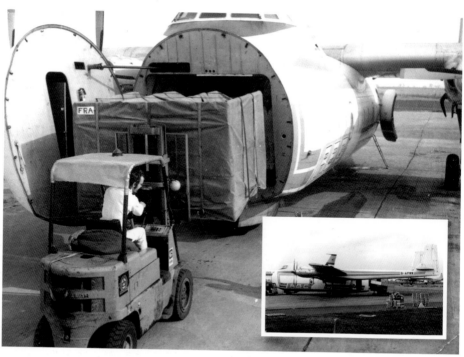

Loading the Armstrong Whitworth Argosy (G-APWW) at Southend. It was built in 1959 and was the second prototype. (*Author's Collection*)

Inset: Loading the Armstrong Whitworth AW654 Argosy (G-APWW) at Southend. (*Author's Collection*)

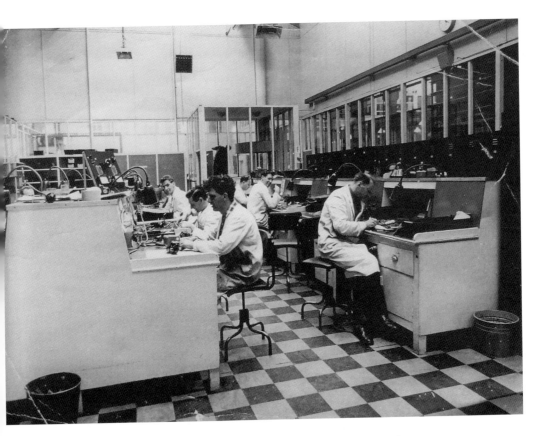

Aviation Traders' engineers workshop in the 1960s. (*Author's Collection*)

James Cole, ex-Warrant
Officer, 644 Squadron RAF
(1939–45) was the Apron
Supervisor at Southend from
around 1948 until the 1970s.
(*Barry Cole*)

Freight Handling at Southend Airport. Left to right: Arthur Williams, Dave Bolton, James Cole, Alan Digby and Bob Banks. (*Barry Cole*)

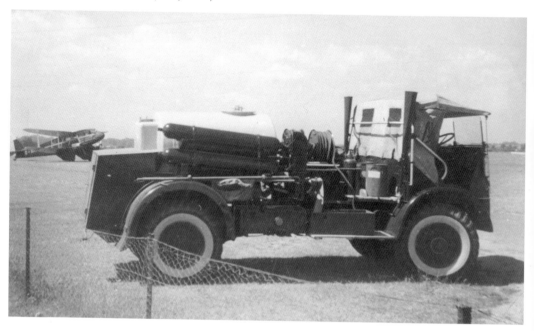

The ex-RAF four-wheel drive Crossley Airfield Fire Tender was replaced by two Merryweather Fire Tenders. (*Barry Cole*)

Two of the 2,500-gallon AEC Matador aircraft refuellers. (*Barry Cole*)

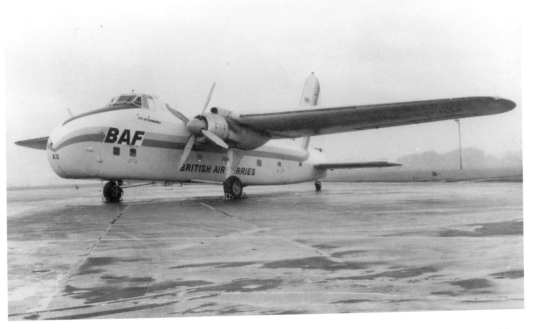

Bristol 170 Freighter Mk 32 (G-APAU) British Air Ferries *City of Edinburgh*. It was later sold on to Midland Air Cargo and was broken up in 1975 (*Graham Mee*)

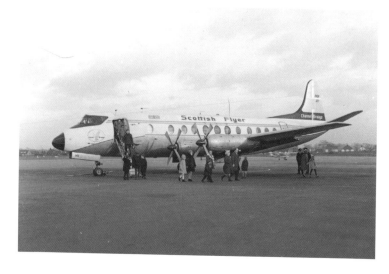

The Scottish Flyer
Service, run by
Channel Airways
around 1966. (*The Ken
Woolcott Collection*)

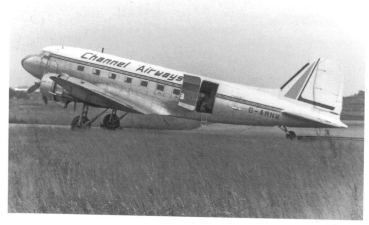

Douglas DC-3 Dakota
(G-AMNW) of
Channel Airways at
Southend on 22 June
1965. (*Keith D. Burton*)

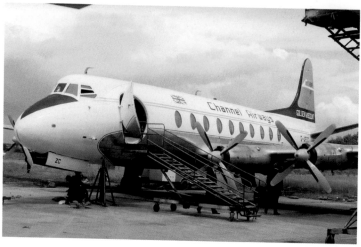

Vickers Viscount (G-
APZC) of Channel
Airways undergoing
maintenance at
Southend in the
summer of 1967.
(*Kevin Haigh*)

De Havilland Dove (G-ANVO) and a Bristol 170 Freighter of Channel Airways on the apron *c.* 1962. (*The Ken Woolcott Collection*)

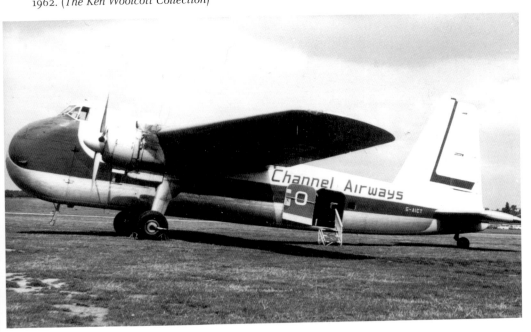

Channel Airways Bristol 170 Mk 21E (G-AICT) around 1965. (*Author's Collection*)

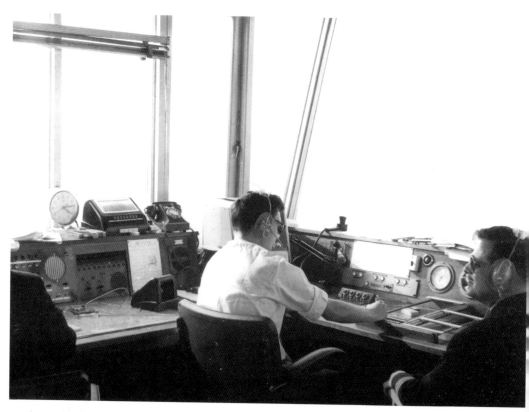

Inside the old Air Traffic Control Tower (the airport commandant, Anthony Cusworth, is on the right). (*The Ken Woolcott Collection*)

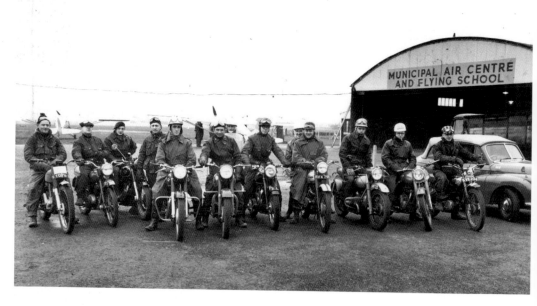

Southend Motorcycle Club gathered at the Municipal Flying Club at Southend in the 1960s. (*Colin F. Pickett*)

A completed Carvair nose, ready for another conversion by Aviation Traders. (*Barry Cole*)

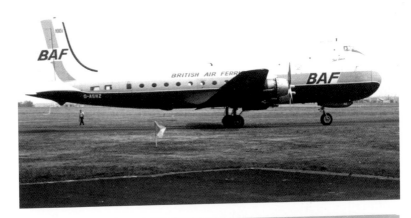

Aviation Traders ATL-98 Carvair (G-ASHZ) *Fat Annie* of British Air Ferries. (*Author's Collection*)

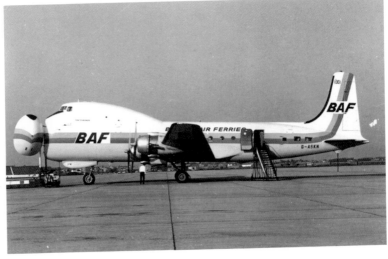

Aviation Traders ATL-98 Carvair (G-ASKN) *Big Bill* was built in 1964 and served with British Air Ferries and British United until 1976, when it was exported to Gabon. (*Author's Collection*)

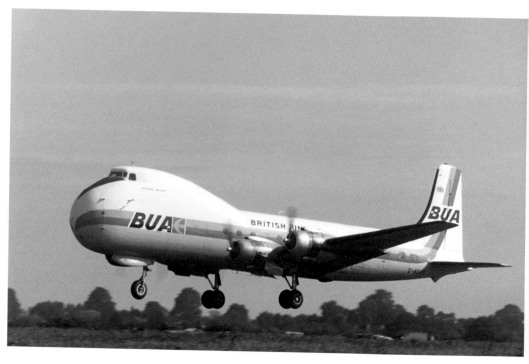

Aviation Traders ATL-98 Carvair (G-ASKG) of British United Airways in 1967. It was originally built by Douglas as a C-54A-15-DC Skymaster for delivery to the USAAF in 1944. (*Kevin Haigh*)

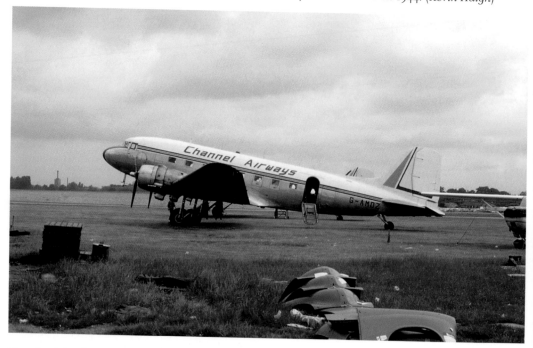

Douglas DC-4 (G-AMOZ) of Channel Airways at Southend. A painting was made of this aircraft alongside a Bristol Freighter at Southend by Malcolm Root, GRA, and was used as a greetings card by Rothbury Publishing. (*Kevin Haigh*)

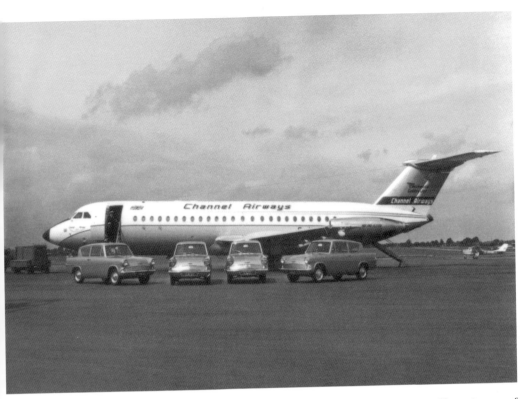

Channel Airways celebrated their 21st anniversary with a competition for its staff to win one of four specially painted (gold) Ford Anglias. (*Graham Mee*)

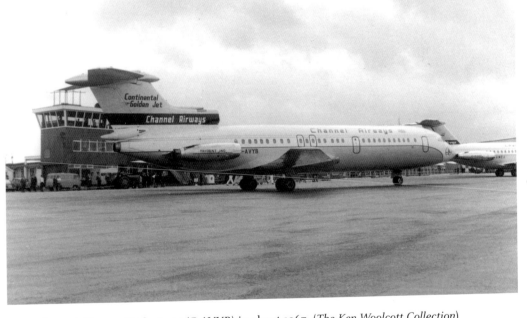

Channel Airways Trident 140 (G-AVYB) in about 1967. (*The Ken Woolcott Collection*)

Hawker Siddeley HS748 (G-ATMJ) in Autair colours around 1967. (*The Ken Woolcott Collection*)

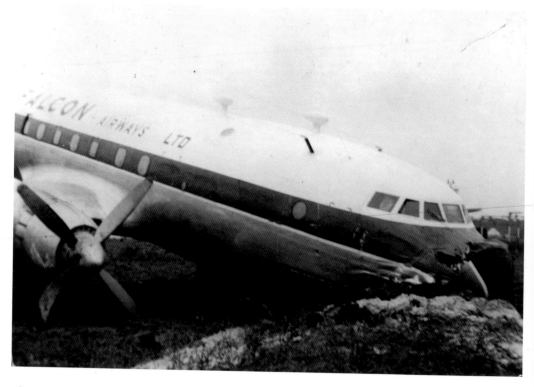

This Handley Page Hermes (G-ALDC) of Falcon Airways crashed on 9 October 1960. (*Barry Cole*)

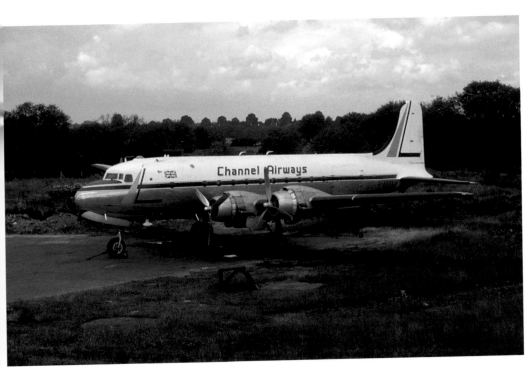

Douglas DC-4 (G-ARYY) of Channel Airways in 1963. (*Kevin Haigh*)

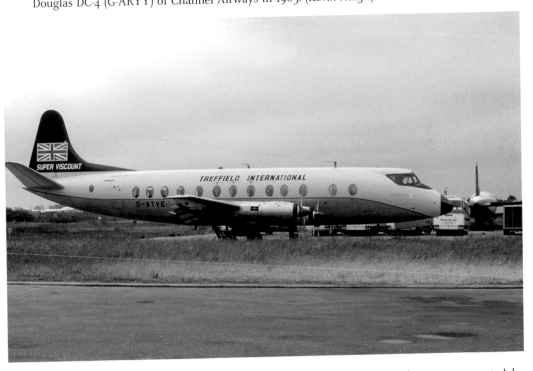

This Vickers Super Viscount (G-ATVE) of Treffield International Airlines was operated by Channel Airways in 1967. (*Kevin Haigh*)

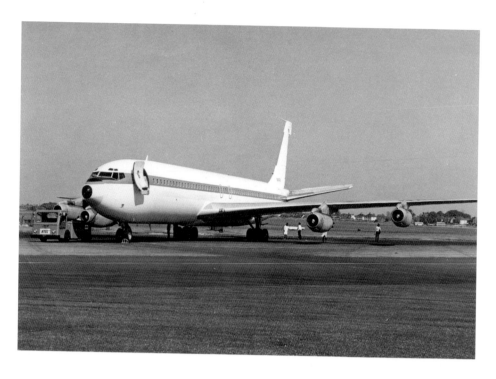

A Boeing 707 (N-IIRV) of Pan American Airlines on a visit to Southend. (*Graham Mee*)

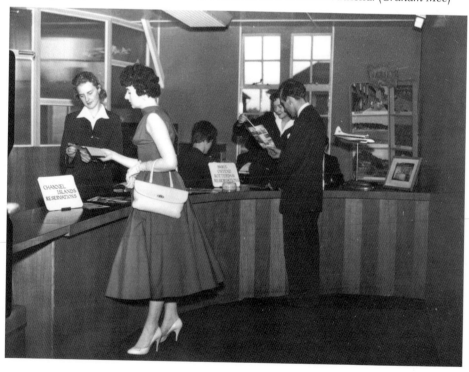

The Check-in for Jersey and European destinations at the Southend terminal in the 1960s. (*The Ken Woolcott Collection*)

Above left: British United Air Ferries flyer. (*Nick Skinner*)

Above right: British United Air Ferries timetable, 1966. (*Nick Skinner*)

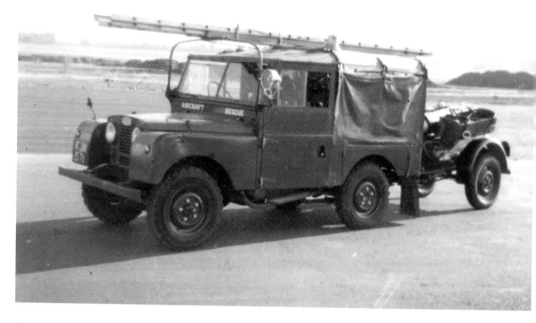

The aircraft rescue Land Rover (CJN571) and powder trailer that were purchased in the 1960s. (*Barry Cole*)

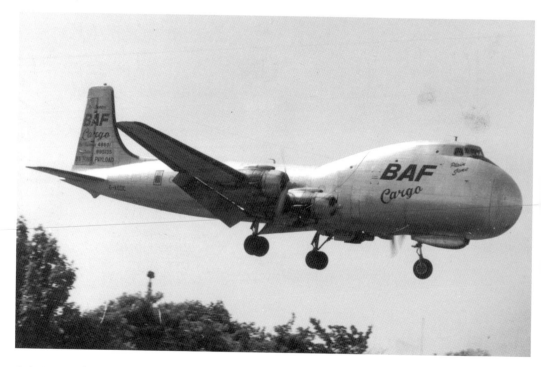

Aviation Traders ATL-98 Carvair (G-ASOC) *Plain Jane* of BAF. (*Author's Collection*)

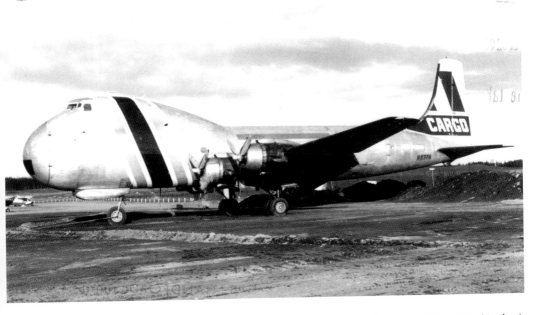

Aviation Traders ATL-98 Carvair (N-83FA) at Southend in the colours of Falcon Air. (*Author's Collection*)

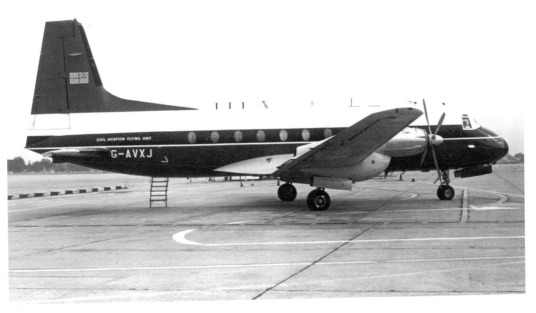

This Hawker Siddeley HS-748 (G-AVXJ) was built in 1969 and served with the Civil Aviation Authority. (*Author's Collection*)

43

1970–1980

On 31 October 1970, BKS Air Transport was acquired by British European Airways and its name was changed to Northeast, which went on to become one of the four component parts of British Airways.

Seawing Flying Club Ltd started in 1971, and from the early 1980s held a Ministry of Defence contract to train RAF, Royal Navy and Army cadets as well as their civil pilot training courses, which proved to be very successful.

In October 1971, BAF's ownership passed from Air Holdings to the Keegan family.

1972 turned out to be one of the bleakest years in the airport's history when at the end of February, Channel Airways, who flew to Paris, the Channel Islands, Rotterdam and Le Touquet, with their fleet of turbo-prop Viscount aircraft, ceased to operate and the company was liquidated. The demise of the company saw the loss of one of Britain's pioneering airlines and a drop in revenue for the airport. The lucrative routes to the Channel Islands were immediately assured by British Midland Airways.

Air Bridge Carriers was formed in this year and operated with four Argosy freighters to fly fresh produce from the Channel Islands to the UK. Supplemental work comprised of ad-hoc charter work, with special emphasis on 'awkward loads' such as aircraft engines and heavy machinery for the North Sea oil fields.

On 26 May, after five years of planning, building and acquisitions, quickly built into one of the UK's largest vintage aircraft collections, the British Historic Aircraft Museum in Aviation Way, opposite the County Hotel, was officially opened by Air Marshal Sir Harry Burton, KCB, CBE, DSO, RAF, then Air Officer Commanding-in-Chief of Air Support Command, RAF. The museum belonged to Tony Osborne and was run and maintained by enthusiasts. Instantly recognised by the Beverley Blackburn (XB261) close to the entrance, it was also home to a big collection both inside and out the museum building which included an Avro Lincoln, Mitchell, Sea Fury, the Haig-Thomas Moth Collection, Chris Storey's Flying Flea, and three Ansons, one of which was E. K. Cole's G-AGPG.

On 29 July, the 'Zero 6' hotel and club was opened by the late disc-jockey

Kenny Everett in Aviation Way; the club was so-called because of its position close to the end of the o6 runway.

One of the hangars used by Channel Airways was acquired by Helicopter Hire Ltd in 1973, and Harvest Air was established and offered charter flights and crop-spraying services.

In 1975, BAF began replacing its remaining Carvairs with Handley Page Dart Herald turbo-props on its cross-Channel routes linking Southend with Le Touquet, Ostend and Rotterdam. It flew its first scheduled flight on 18 April and resulted in the Carvair services being converted into ordinary passenger schedules and the Carvairs themselves were transferred to cargo flying.

On 1 April, BAF flew the first scheduled flight to Ostend in a Herald (G-BC2G).

Sabena (Belgian World Airline) brought shoppers in from Belgium with their Boeing 737s and there were as often as many as three a day coming in to Southend.

On 1 January 1977, BAF operated its last car ferry service. Later the same year, on 31 October, history was made when a BAF Herald operating the airline's inaugural scheduled passenger flight from Southend to Düsseldorf under the command of Captain Caroline Frost became Britain's first airliner flown by an all-female crew.

This year also returned the lowest freight transport figures since 1954.

The noise levels of the Channel Airways BAC 1-11 and subsequent complaints they drew from the local residents on the flight path off o6 became a serious issue when night flights began: 01.50 hrs and another two hours later. This issue was compounded by Viscounts commencing night flights. This was brought about by the offer of a reduction in fares to entice people to travel at night (the reasoning being that an aircraft doesn't make any money until it is in the air).

On 1 January 1979, BAF transferred its entire scheduled operation including associated aircraft and staff to British Island Airways (BIA).

The era of the Carvair, the aircraft that had become a symbol for Southend Airport, came to an end and 'Plain Jane' made its last flight in April, and then was retired from service.

TAC/Heavylift, which was formed at Stansted in 1978 (and later became Heavy Lift Cargo Airlines), bought the lease on the former Aviation Traders hangars and began an extensive engineering programme of converting a fleet of ex-RAF Belfasts from military to civilian specifications.

BAF withdrew from scheduled service operations to concentrate on other activities, such as leasing, and British Island Airways took over the scheduled routes.

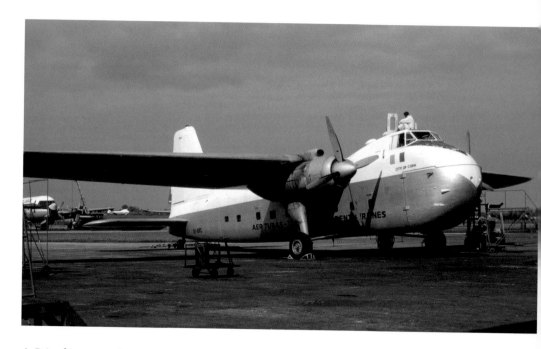

A Bristol 170 Freighter Mk 31 (EI-APC) in July 1972. Bought by Aer Turas in March 1966 and flying in three different colour schemes during a six-year career with the airline, this Freighter was passed to Skyways as G-AMLJ and then to MEA, BOAC Associated Companies and BKS. It was scrapped at Nice in 1976. (*Richard Vandervord*)

Vickers 836 Viscount 501 in October 1971. Following preparatory work by ATEL, she spent her career in the UK as B-BFZL and ended her days in Congo, crashing during a three-engined take-off from a 900m strip in April 2003 registered as 9Q-CGL. (*Richard Vandervord*)

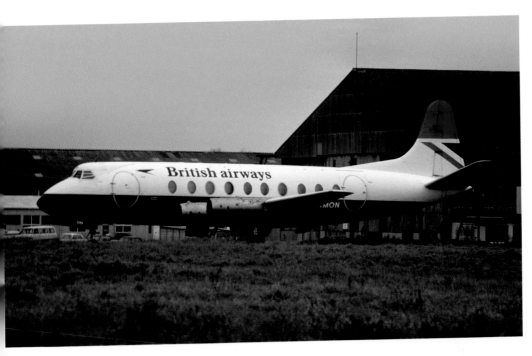

This Vickers Viscount V.701 (G-AMON) is seen here after it had been withdrawn from use, but still with British Airways titles at Southend Airport on 27 December 1976. (*Trevor Hall*)

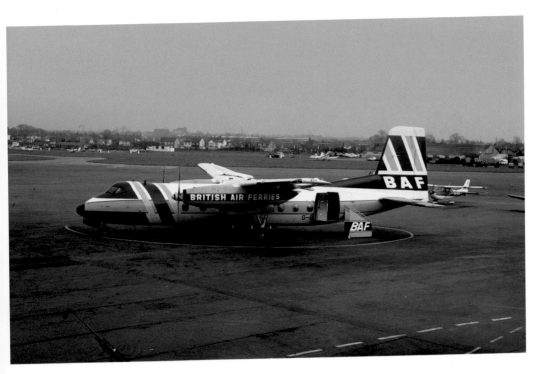

A British Air Ferries Herald at Southend on 27 December 1976. (*Trevor Hall*)

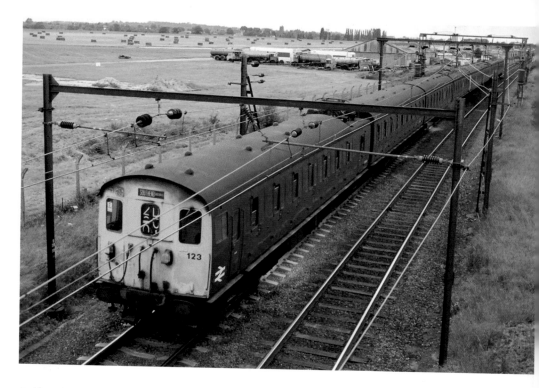

A Class 307 EMU (307123) passing Southend airport on its way to Southend from Liverpool Street in July 1979. Note the Corporation bowsers and tankers on the airfield. (*David Ford*)

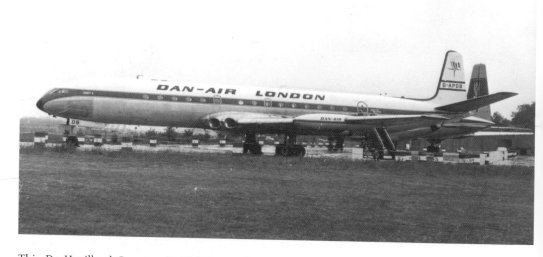

This De Havilland Comet 4 (G-APDB) was the first of two Comet 4s for BOAC, delivered on 30 September 1958. It joined Dan Air in 1970, and flew the first jet services across the North Atlantic, New York–London. It was broken up in 1974 and is now preserved at Duxford. (*Author's Collection*)

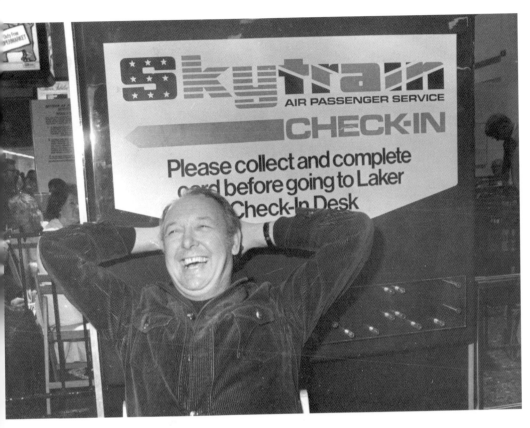

Freddie Laker at the launch of Skytrain in 1977. (*Author's Collection*)

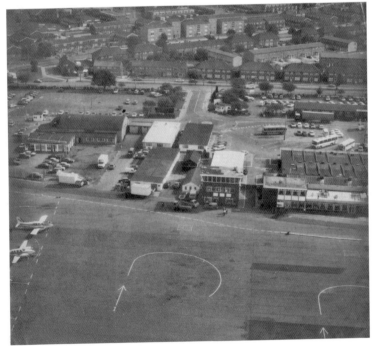

An aerial photo of Southend airport showing the coach park and the 'Long Rooms' close to the south entrance in the 1970s. (*Graham Mee*)

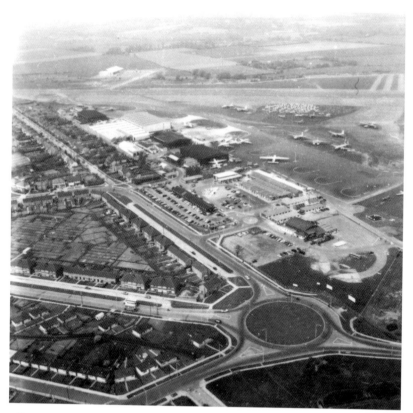

An aerial photo showing the southern and western areas of Southend airport in the 1970s. (*Graham Mee*)

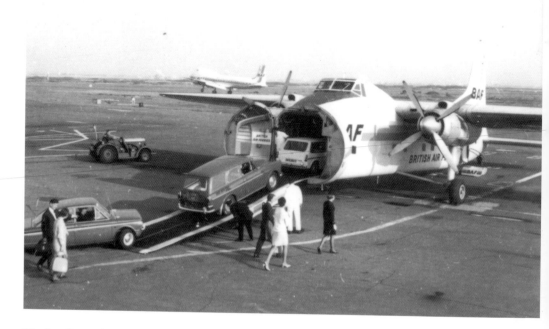

The familiar sight of a British Air Ferries Freighter being loaded in the 1970s. (*Graham Mee*)

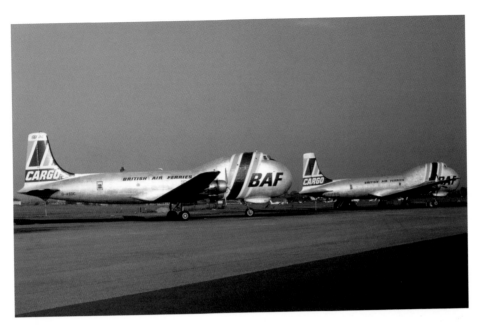

An Aviation Traders ATL-98 Carvair (G-ASDC) in December 1977. One of Southend's last two operational Carvairs, it is seen here in the company of G-ASHZ. (*Richard Vandervord*)

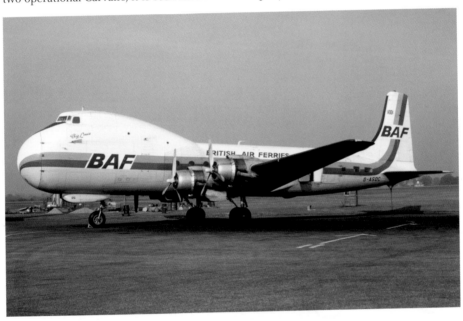

An Aviation Traders ATL-98 Carvair (G-ASDC) in April 1974. Converted by ATEL from a DC-4 (LX-BNG) and first flying as a Carvair in March 1963, it was first christened *Pont du Rhin* by BUAF and was renamed *Plain Jane* by BAF in 1972. It was sold to Falcon Airways of Texas as N80FA in April 1979. (*Richard Vandervord*)

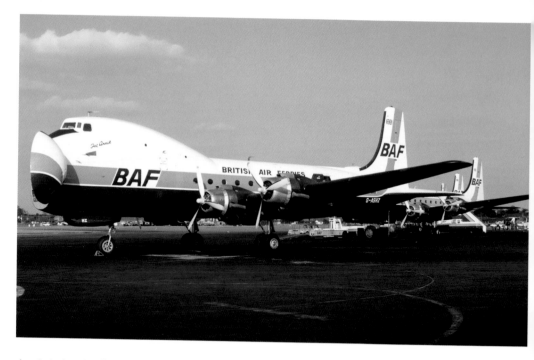

An Aviation Traders ATL-98 Carvair, *Fat Annie* (G-ASHZ), in a typical ramp scene in the mid-Seventies with four Carvairs on turn-around in August 1974. (*Richard Vandervord*)

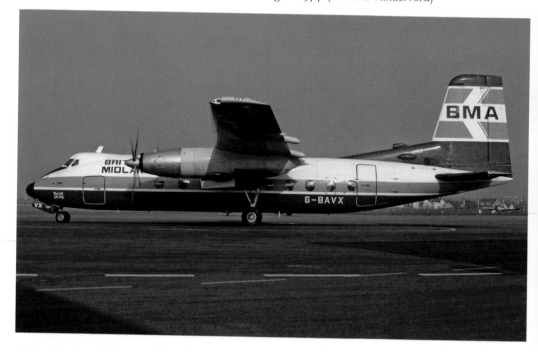

A Handley Page HPR-7 Herald 214 (G-BAVX) at Southend in 1975. A familiar sight at Southend during her BAF career, this former Sadia Herald ended her days as G-DGLD with Channel Express and was scrapped at Exeter in 1996. (*Richard Vandervord*)

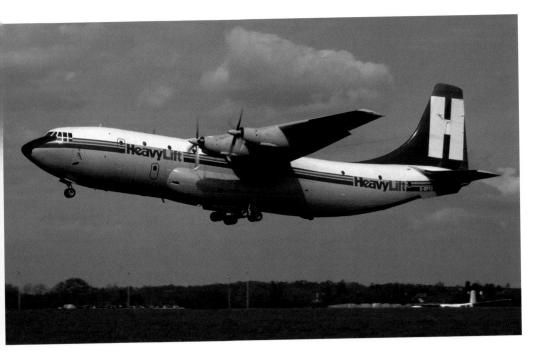

Short SC-5 Belfast (G-BEPS) in April 1979. This very special machine was sadly broken up at Southend on 23/24 October 2008 after plans to put it back in service fell through. (*Richard Vandervord*)

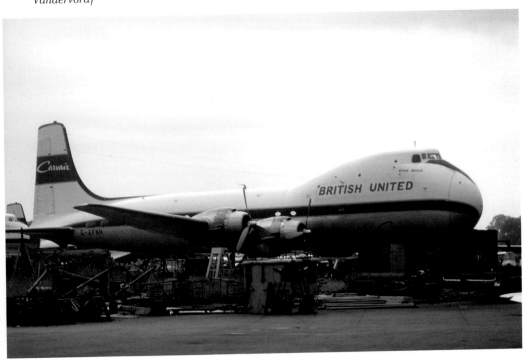

An Aviation Traders ATL-98 Carvair (G-APNH) resting on a trolley after a nose-wheel collapse on 18 March 1971. The aircraft was damaged beyond repair. (*Kevin Haigh*)

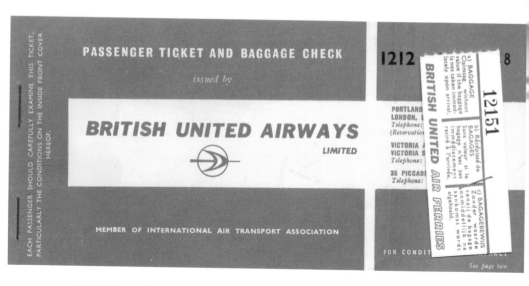

British United Airways ticket. (*Author's Collection*)

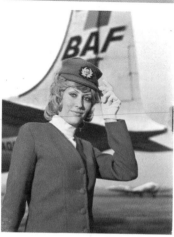

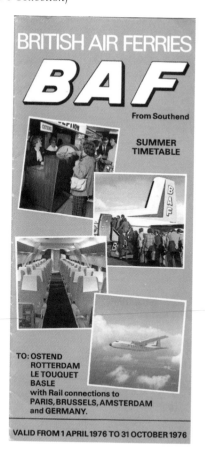

Above left: British Air Ferries timetable, 1973. (*Nick Skinner*)

Above right: British Air Ferries timetable, 1976. (*Nick Skinner*)

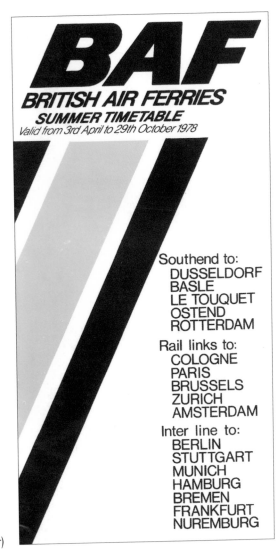

BAF
BRITISH AIR FERRIES
SUMMER TIMETABLE
Valid from 3rd April to 29th October 1978

Southend to:
DUSSELDORF
BASLE
LE TOUQUET
OSTEND
ROTTERDAM

Rail links to:
COLOGNE
PARIS
BRUSSELS
ZURICH
AMSTERDAM

Inter line to:
BERLIN
STUTTGART
MUNICH
HAMBURG
BREMEN
FRANKFURT
NUREMBURG

British Air Ferries timetable, 1978 (*Nick Skinner*)

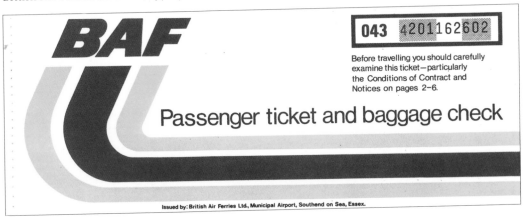

BAF

043 4201162602

Before travelling you should carefully
examine this ticket—particularly
the Conditions of Contract and
Notices on pages 2–6.

Passenger ticket and baggage check

Issued by: British Air Ferries Ltd., Municipal Airport, Southend on Sea, Essex.

British Air Ferries ticket and baggage check. (*Nick Skinner*)

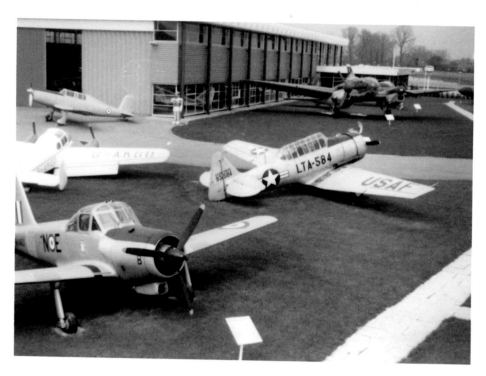

The Historic Aircraft Museum in 1975, showing the Hunting Percival Provost T.1 (WV483); North American T-6 Harvard IIB (LN-BNM); Miles M.65 Gemini 1A (G-AKGD); Fiat G.46 (MM53211); CASA 211 (G-AWHB); and not to forget the 7-foot-tall robot in the centre background. (*Geoff Whitmore*)

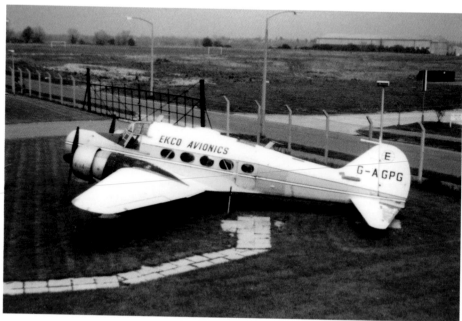

The 'Ekco' Avro Anson (G-AGPG) on display at the Historic Aircraft Museum in 1975. (*Geoff Whitmore*)

An Avro Lincoln B2 (G-APRJ), fitted with a modified Lancaster nose, on display at the Historic Aircraft Museum in 1975. (*Geoff Whitmore*)

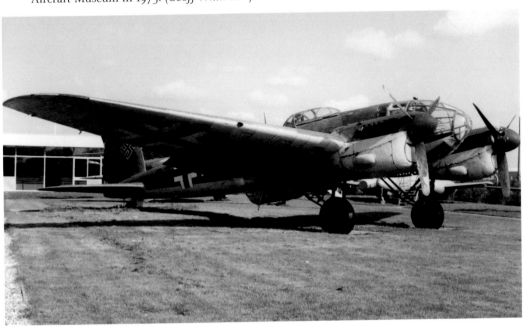

The Heinkel He-111H on display at the Historic Aircraft Museum in 1975 (B2-137) was featured in the film *Battle of Britain*. (*Author's Collection*)

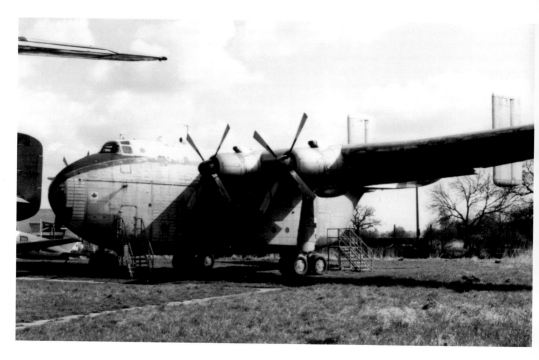

The Blackburn Beverley C1 (XN261) sits in a sorry state towards the end of its time at the Historic Aircraft Museum. (*Author's Collection*)

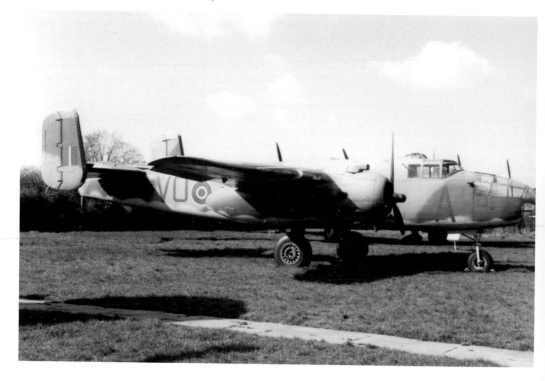

The B-25 Mitchell (N9089Z) was used as a camera ship for the filming of *The War Lover* and *633 Squadron*. (*Author's Collection*)

Historic Aircraft Museum brochure cover. (*Author's Collection*)

1980–1990

In the 1980s holiday flight companies set up at the airport, bringing a change of fortune to the airport after a steady decline in the number of passengers. Tradair brought Vickers Vikings into Southend, ex-Queen's Flight aircraft, one being the Queen's personal aircraft. British United Airways formed by amalgamating Airwork Ltd, Transair Ltd, Hunting Clan Airways and Air Charter Ltd. Routair Flying Services was established and operated flights to the Middle East, and British Island Airways merged with Air Anglia to form Air UK.

1981 saw Jersey European Airways begin flying mail for the GPO, and Horizon Holidays started a successful season of flights to Tenerife with Orion Airways Boeing 737s.

BAF acquired an entire fleet of Viscount aircraft along with the spares inventory after British Airways withdrew its loss-making regional routes. With such a large increase in the fleet, BAF became the world's largest operator.

The British Historic Aircraft Museum, which had been plagued by management problems from the start, fell into neglect and was subject to vandalism. Despite coming under the new management of Bill Gent in 1980/81, it was decided that it had become necessary to sell some of the exhibits to raise funds to bring the museum back up to standard; these went under the hammer in 1983.

The issue of noise was raised again as the number of flights going out during the night exceeded those in the daytime but it wasn't until the end of the 1980s that some measures were introduced by way of loose restrictions on night operations which included the banning of all jet movements apart from the BAE 146.

In May 1982, Harvest Air won a contract for oil pollution and spraying for the Department of Trade, and had purchased eight aircraft including BN-2A Islanders which had been specially converted for the purpose and two Douglas Dakotas which had been adapted as heavy spray tankers. They operated on 30-minute stand-by from Southend, Kinloss, Exeter and Prestwick.

Cosmos Holidays started inclusive tour flights to Palmera and Gerona with Monarch Airline Boeing 737s, and the Skylane Centre opened, which provided professional pilot training at all levels.

In 1983, the Keegans put some of their businesses into receivership and in March of that year they sold the British Air Ferries name along with the airline's commercial flying operations to the Jadepoint investment group for £2 million.

Burstin Travel began flights to Malta during the summer, and the venture proved so popular that the tours were extended to the winter months. The trend continued and 1985 saw a complete sell-out for holiday flights which by then included Faro, Portugal.

In 1984, Routair Flying Services was officially recognised as one of the UK's largest air taxi/charter companies with a fleet of seven aircraft.

The dock strike gave Southend a large boost in airlift operation, involving extra flights and 1,500 tonnes of freight.

Heavylift Cargo Airlines set up a new company, Heavylift Engineering, to perform contract maintenance at Southend, and Maersk Air started scheduled flights to Billund in Denmark.

The first Airshow was held on the May 1986 Bank Holiday as part of the Southend Spring Festival; it was Europe's largest free airshow at the time. Burstin travel started operating Boeing 727 airliners upon expansion of their holiday destinations out of Southend, and National Airways moved to Southend from Luton, operating flights for several travel companies including DHL Courier.

The delta-wing Avro Vulcan bomber XL426, which had been a part of the Vulcan Display Flight in June 1984, was purchased by businessman Roy Jacobsen and arrived at Southend from RAF Scampton in December 1987 for vital engineering work, to enable it to continue to display as a civilian aircraft, but the enormous costs prevented this from being carried out. In July 1987 XL426 was placed on the civil register as G-VJET. Plans to return the aircraft to air-worthy condition fell through; it was only saved from the cutting torch when the Vulcan Memorial Flight Supporters Club offered to pay off part of the debt on the condition that Jacobsen passed the ownership of XL426 to the club. In July 1993 a deal was made and the airport agreed to lift the threat of scrapping. Shortly afterwards the club re-constituted itself as the Vulcan Restoration Trust. The aircraft is still at the airport – parked close to the eastern perimeter fence that runs alongside the railway line and Rochford Road, just north of the Flight Centre and the Lancaster Restaurant. The aircraft has been carefully restored and there are periodic engine tests and although the last fast taxi run took place in 1976, it now only has open days and cockpit tours during the year; it would be unrealistic to expect that she will fly again.

Harvest Air lost its tender for the Government contract to disperse oil slicks at sea to a rival bidder. Air Atlantique bought all the specially-adapted aircraft from Harvest Air but employed none of the personnel.

The Historic Aircraft Museum sold off the remainder of its vintage aircraft (although the Blackburn Beverley was eventually scrapped) and the big display hall became a skating rink called Roller City.

The hurricane of 16 October 1987 caused a great deal of damage in south-east Essex and locally was worse than the storm of 1976, causing a great deal of damage; at the airport it caused a hangar to crash down onto parked aircraft.

In 1988 Southend Airport was rated the fourth busiest in the UK in terms of aircraft movements. However, BAF went into administration in January, and a new holding company, Mostjet, was formed within a year to enable the airline to emerge from administration in May 1989, the only British airline to do so at the time. Two years later, BAF announced profits of over £1 million, mainly through their BAC- 1-11s and ski charters on behalf of Crystal Holidays.

The 1980s ended on a sour note for the airport with the demise of the Burstin organisation and the collapse of Regionair.

Flightline was formed in 1989, operating ad-hoc charters (mainly with BAE 146 aircraft) from its headquarters at the airport along with a maintenance/engineering base for their own and third party aircraft.

In July 1989, the Airport Duty Crew Firemen uncovered one of the Pickett-Hamilton Forts, which despite being under the earth for almost fifty years, was still in good working order. It was removed and was to be crushed but was rescued and is now in preservation.

Chief Flying Instructor Clack of the Southend Flying Club.
(*Ian Longshaw*)

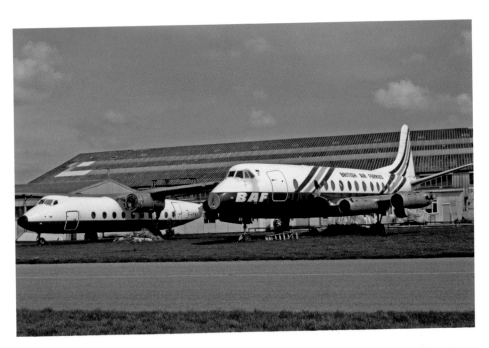

A Vickers 806 Viscount (G-APEX) in May 1985. This well-known ex-BEA Viscount had been with BAF for about six months at the time this photograph was taken and was withdrawn from use in early 1984. Only the fuselage was retained and survived another 10 years. (*Richard Vandervord*)

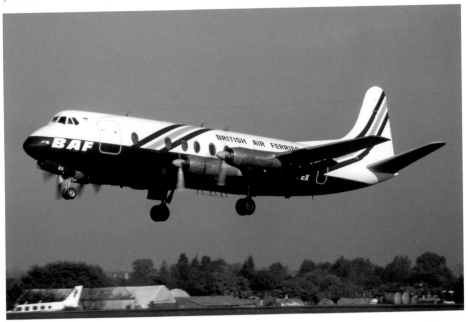

Another view of the Vickers 806 Viscount (G-APEX) in October 1981. (*Richard Vandervord*)

1990–2010

In the 1990s, Heavylift begin a £1 million refurbishment of their hangar. Southend Airport ordered its new Instrument Landing System (ILS) for installation in April 1992 and Refurbishair opened their new facility.

Princess Air, which was formed by Burstin Travel, began charter flights at Easter 1990 with the BAE 146-200 from Southend and Bournemouth to holiday destinations in Europe, and operated freight flights at night between Cologne and Brussels. However, the company ceased operations in February 1991 as the night contracts were short-term and not renewed, and a decline in the market impacted on its daytime services.

In 1991, the annual Southend Airshow was extended into a two-day event, and has taken place every year since over the Spring Bank Holiday – Sunday 27 and Bank Holiday Monday 28 May.

ATC Lasham is the major engineering company at the airport, having taken over from the old Heavylift Engineering Company. Other companies include Air Livery (aircraft re-finishing), Avionicare, BAC Engineering, Flightline Aircraft Engineering, IAVNA (airport visual aids), Inflite Engineering (previously World Aviation Support and BAF Engineering), IPECO/Benson-Lund and JRB Aviation.

In April 1993, BAF was renamed British World Airlines (BWA), and the company executed a thorough redesign of its corporate image, including a sleek new leaping lion logo.

In early 1994 Southend Borough Council were proposing to either privatise the Airport or to close it down, the latter of which would have had a detrimental effect on Southend and indeed, this part of Essex. However, in March, the Airport was sold to Regional Airports Ltd (RAL) and was re-branded as London Southend Airport in order to highlight its importance and accessibility to London and the City; the word 'Municipal' was dropped from the title.

A year later, RAL completely refurbished the airport's terminal building, resurfaced the runway, demolished many of the old decrepit buildings and redecorated many others. The airport was transformed, and on 26 May 1995, the official terminal reopening took place.

Following this came the cessation of the scheduled night flights that had given rise to so many complaints.

Holland Aero Lines became a familiar sight in 1995 with their Rotterdam to Southend service operating three times a week until 1996.

In 1998, the Deputy Prime Minister John Prescott gave the go-ahead for London Southend Airport to build a new passenger terminal and railway station offering air passengers faster links to London.

BWA ceased trading on 14 December 2001, as a result of the steep decline in trade following the events of 9/11.

Heavylift's fleet of Belfasts had been slowly reduced until only two were operational during the 1990s and by the time of the demise of the airline on Friday 13 September 2002, only G-HLFT remained in service. Following its collapse at Southend the company was re-launched in Australia and, keeping G-HLFT, it was moved to Prestwick, where it was prepared for the long journey across the globe.

In 2006 the famous Boeing B-17 Flying Fortress *Sally B* came to Southend for restoration to her former glory, having been grounded for over a year. On 17 September she arrived at Air Livery PLC, where she was stripped back to bare metal, primed and re-sprayed in the same colour scheme as before, complete with Sally B and *Memphis Belle* nose art. She is the flagship of the American Air Museum at Duxford and has performed at airshows over the UK for over thirty years.

Another restoration project was that of Boeing 707 VH-XBA. After being stored for several years, it was rescued by a group of Australian engineers, restored and painted in Qantas period livery and flown back to Australia, where it now sits at the Quantas Founders Memorial Museum. It is significant as it was the first jet aircraft delivered to Quantas and also exported from America.

On 28 January 2008, RAL announced that the airport was being put up for sale in order to find the investment needed to fulfil the potential of the airport as London's sixth airport.

After an extended bidding process, with many major airport operating companies involved, the airport was purchased on by the Stobart Group, the large British multimodal logistics company, on 2 December for £21 million, becoming part of the Stobart Air division, which also operates Carlisle Airport. Stobart negotiated a £100 million loan from M & G Investments, and part of this funded the construction of the new railway station, which began in 2009 after discussions with Network Rail, National Express and the Department for Transport.

Flybe began operating a weekly seasonal service to Jersey using Dash-8 aircraft, but this ended in 2011 after easyJet announced that

they would be operating the route on a daily basis.

The redevelopment of the eastern perimeter of the airport began in 2009 and included the demolition of the American-style B52 Bar Diner, and disused wartime buildings in order to make space for the long stay car park for the new railway station. The Seawing Flying Club was relocated to the western side of the ATC Lasham hangars, next to the Southend Flying Club, in September 2011.

Work also began on the new control tower by Readie Construction of Romford, which would be equipped with state-of-the-art, dual-channel, Selex SI radar, and the railway station.

On the southern perimeter of the airport, Willmott Dixon began construction on 25 July of the five-storey, 129-room four-star Holiday Inn hotel (Holiday Inn being the official hotel provider for the London 2012 Olympic and Paralympic Games).

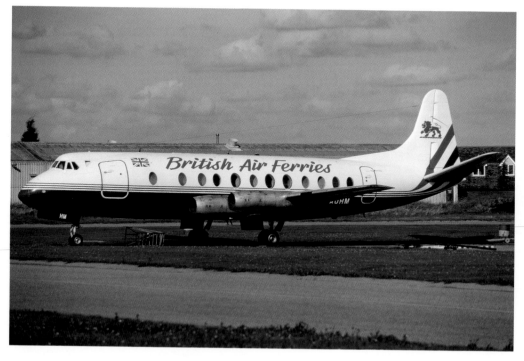

A Vickers Viscount 802 (G-AOHM) at Southend on 6 October 1991. (*Chris Chennell*)

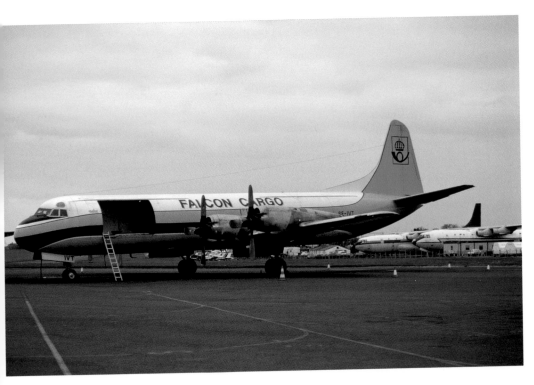

A Lockheed L-188C (F) Electra (SE-IVT) at Southend on 8 March 1992. (*Chris Chennell*)

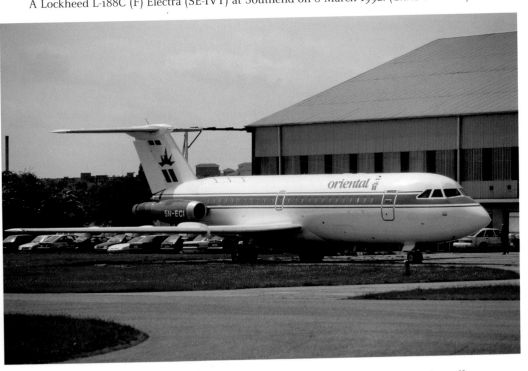

A BAC 111-476FM One-Eleven (5N-ECI) at Southend on 31 May 1996. (*Chris Chennell*)

Aerial approach in a helicopter on 31 May 2004. (*Dan Davison*)

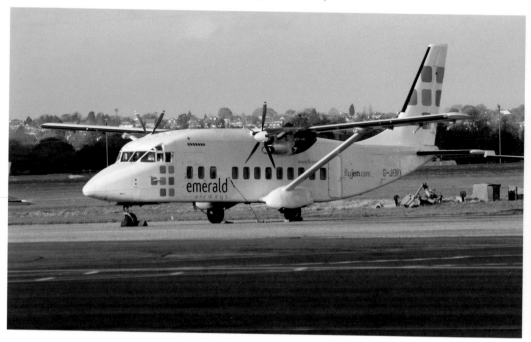

A Short 360 (G-JEMX) of Emerald Airways on 4 December 2006. (*Ian Press*)

A Boeing 707-373C (9L-LDU) departing Southend for Malta on 11 October 2003. (*Keith D. Burton*)

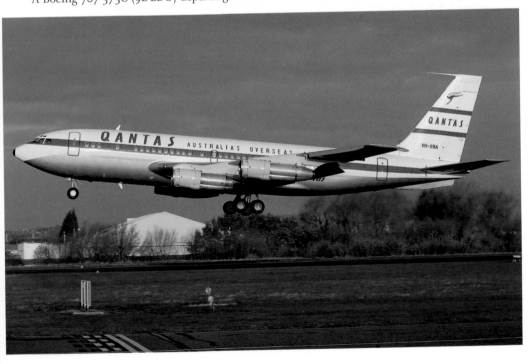

A Qantas Boeing 707-138B (VH-XBA) at Southend on 5 December 2006. (*Keith D. Burton*)

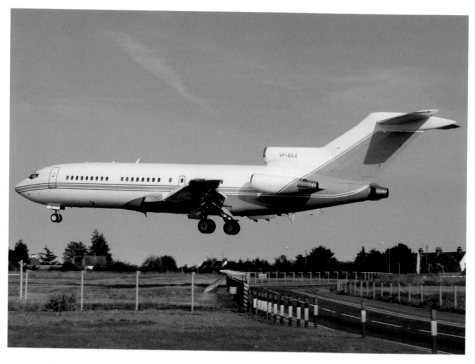

This Boeing 727-51 (VP-BAA) illustrates a low approach across Eastwoodbury Lane on 30 June 2006. (*Keith D. Burton*)

Viscount House, adjacent to the old terminal, on 11 October 2008. (*Author's Collection*)

The American-style B52 Bar Diner on the eastern perimeter road on 16 May 2009; the club was owned and run by American car, motorcycle and music enthusiast Russ Willson and his wife Andrea. It was closed on 3 May 2009 and the grounds used as part of the new long-stay car park for the railway station. (Author's Collection)

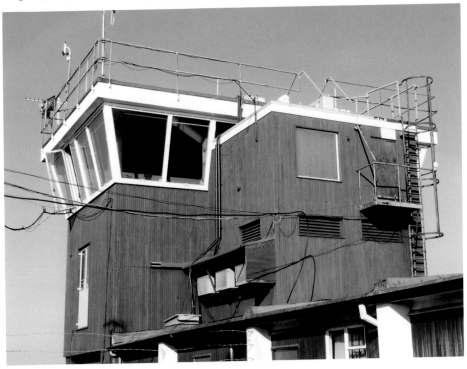

The ATC Tower on 11 October 2008. (*Author's Collection*)

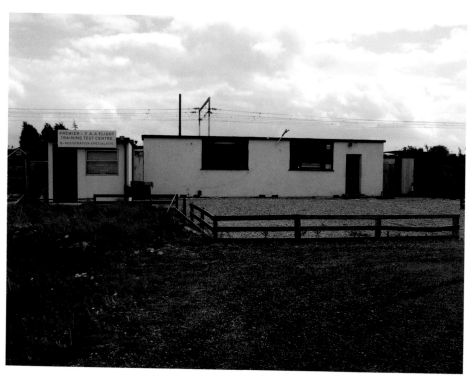

The training test centre on 16 May 2009; this was one of the buildings destined to go during the redevelopment of the eastern perimeter. (*Author's Collection*)

Disused wartime building on the eastern perimeter in May 2009. (*Author's Collection*)

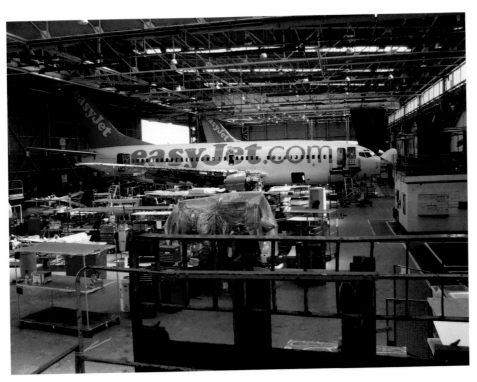

easyJet 727 aircraft undergoing checks at ATC Lasham in May 2009. (*Author's Collection*)

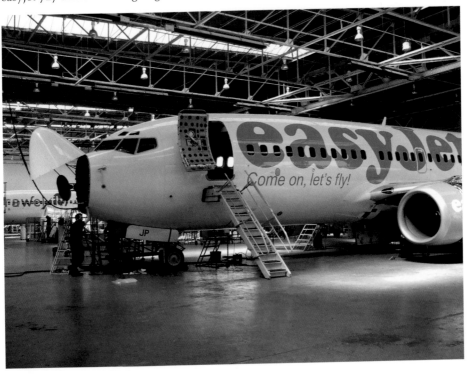

easyJet 727 aircraft undergoing checks at ATC Lasham in May 2009. (*Author's Collection*)

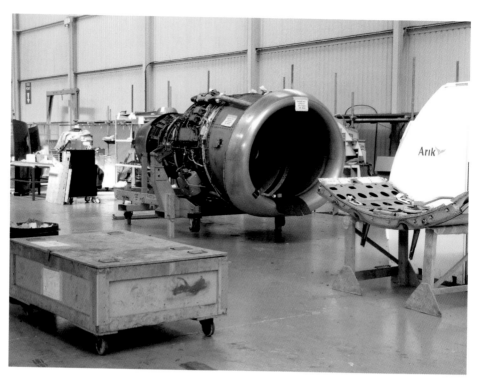

Complete engine testing at ATC Lasham in May 2009. (*Author's Collection*)

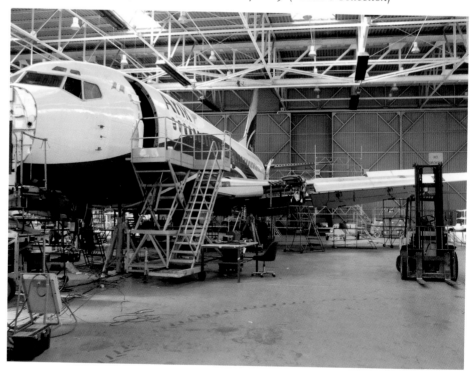

Heavy maintenance at ATC Lasham in May 2009. (*Author's Collection*)

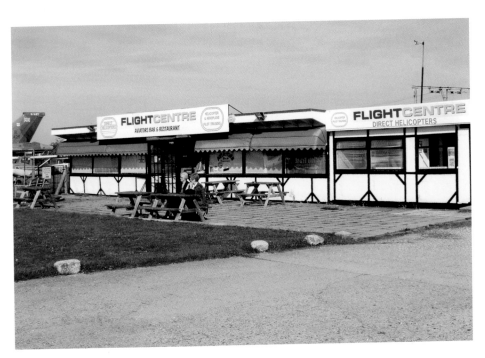

The Flight Centre on the eastern perimeter in October 2008. This became home to the Lancaster Restaurant. (*Author's Collection*)

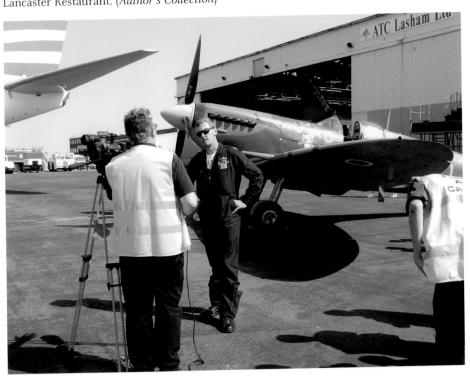

Squadron Leader Al Pinner announces his plans to retire from the Battle of Britain Memorial Flight to a television crew at the Southend Air show of 2009. (*Author's Collection*)

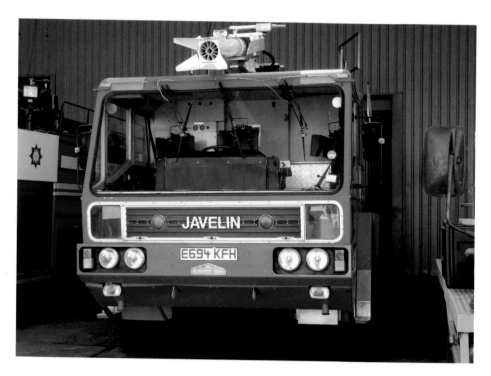

The Gloster Saro Javelin fire appliance (E694 KFH) at Southend in May 2009. (*Author's Collection*)

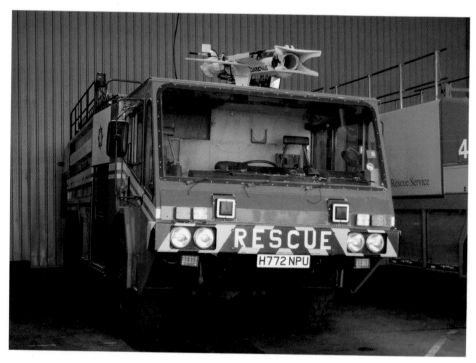

The Unipower RAS6P 6 x 6 airport rescue truck (H772 NPU) at Southend in May 2009. (*Author's Collection*)

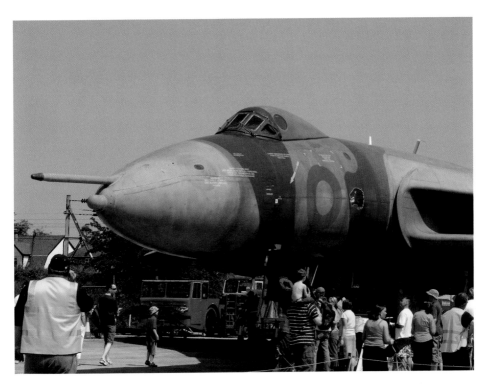

Avro Vulcan XL 426 in May 2009, one of its quarterly open days throughout the year. (*Author's Collection*)

Access road for the plant on the site of the new railway station in July 2009. (*Author's Collection*)

Panoramic view in May 2009 of the cleared grounds where the new railway station would be built. (*Author's Collection*)

Cleared ground for the new development on the eastern perimeter. (*Author's Collection*)

The new perimeter road and site for the new ATC tower in July 2009. (*Author's Collection*)

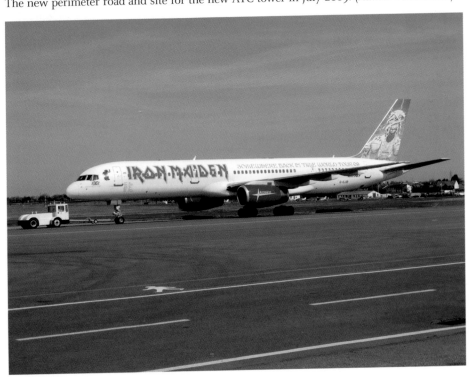

Boeing 757 (G-OJIB) Iron Maiden World Tour 2009 on the tug at Southend. (*Ian Press*)

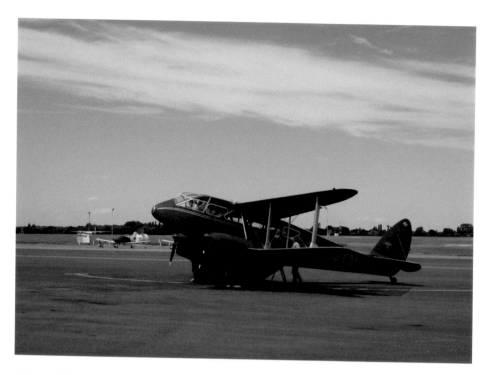

A beautifully preserved Dragon Rapide on the apron on 22 June 2008. (*Terry Joyce*)

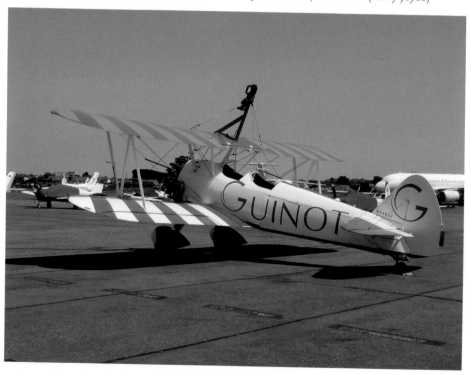

A Boeing A-75N1 Stearman (N54922) of Guinot at Southend for the air show in 2009. (*Author's Collection*)

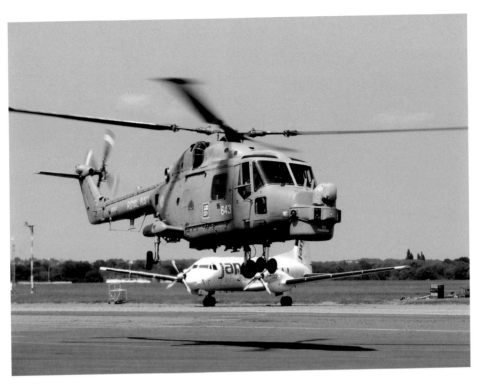

A Westland Lynx HAS3 military helicopter (ZD265) at Southend for the air show in 2009. (*Author's Collection*)

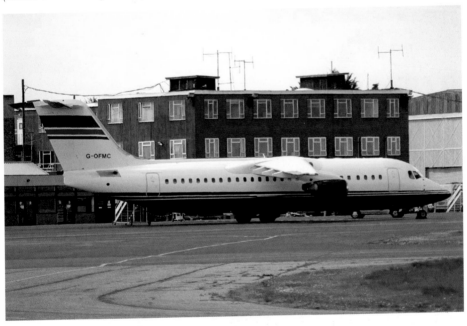

Bae Avro 146-RJ100 (G-OFMC) in Fordair Livery on 19 April 2008. It was used for Ford's Southend to Cologne shuttle and was operated on their behalf by Flightline until they went into administration in 2008. (*Trevor Buckland*)

Viscount House offices in October 2008. (*Author's Collection*)

The old office block used by Flightline and Willow Air in October 2008. (*Author's Collection*)

2010–2012

The new terminal building, with the principal contractor being Buckingham Group Contracting Ltd, was officially opened on 5 March 2011 by the Secretary of State for Transport, the Rt Hon. Justine Greening MP, accompanied by Andrew Tinkler (CEO Stobart Group), William Stobart (COO Stobart Group), Alastair Welch (Managing Director, London Southend Airport) and Carolyn McCall (CEO, easyJet).

The new ATC tower became operational on 21 March, and the new railway station, which was constructed by Birse Rail in conjunction with Stobart Rail, was first in use on 18 July 2011 for passengers, and was officially opened on 21 July 2011 by Minister for Transport Theresa Villiers MP, Stobart Group CEO Andrew Tinkler, COO William Stobart and Stobart Air Managing Director Alastair Welch. The station has the distinction of being completely staffed by Stobart Rail employees.

A diversionary road (named at the opening as St Laurence Way) was constructed by Stobart Rail in advance of the closing of Eastwoodbury Lane, which lay in the path required for the runway extension and was closed permanently from 1 September 2011. McArdle were appointed by Stobart Rail as earthworks and stabilisation sub-contractor for the crucial 300 metre extension, with work beginning in earnest on 11 September.

The regional carrier Aer Arann became the first Irish commercial airline to use London Southend airport, on 27 March 2011, with a fleet of twelve ATR turboprop (they operate a mixture of ATR72 and ATR42) aircraft making daily flights to Waterford and Galway. Aer Arann also based an ATR42 at Southend as part of the Aer Lingus Regional franchise agreement, to fly a thrice-daily service to Dublin from May 2012.

At 7 a.m. on 2 April 2012, easyJet, the UK's largest airline, operated its inaugural flight from Southend (its eleventh UK base) to Belfast after signing a ten-year contract with Stobart Group, to operate around seventy flights per week. The company based three Airbus A319 aircraft and created jobs for over 150 easyJet employees, with many more airport employees to handle the upturn in traffic. Passenger numbers are anticipated to exceed 800,000 in the first year of operation. Flights to eight European destinations were launched and a ninth, to Jersey, began in May.

EasyJet's 200th aircraft, an Airbus A320, performed a special one-off fly-past just off the seafront on the first day of the 2012 airshow, exactly one year after its delivery on 26 May 2011; the crew had to be specially trained for the show.

The new control tower; extended runway; airport railway station, providing fast and frequent train services direct to Stratford (for the 2012 Olympic Games) and London Liverpool Street; new passenger terminal; and airport Holiday Inn hotel make up the development highlights under Stobart Group's ownership. The airport is predicting passenger growth to two million passengers per year by 2019, and in readiness has already had planning approved for a 90-metre extension to the terminal to create space for additional check-in desks and a larger departure lounge.

As it stands today, the Airport is one of the largest employment sites in Southend in terms of jobs, with around fifty tenant companies employing some 1,300 people between them. The airport, with its new railway station and integrated passenger terminal, will encourage greater use of the airport and railway in accordance with the Government's objectives for better facilities in London and the South East within the Thames Gateway. With the railway station, the travel time by train to London is only 53 minutes, making the airport a credible London airport.

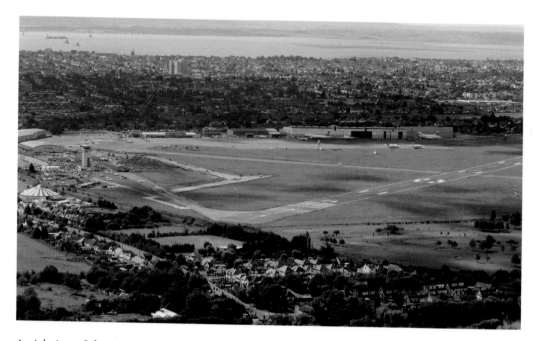

Aerial view of the airport and redevelopment in April 2012. (*Jackie Bale, LRPS*)

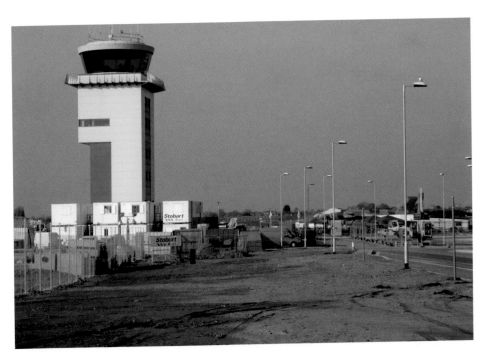

The new Air Traffic Control Tower and close-by development under way on 11 March 2012. (*Chris Chennell*)

Construction of the new railway station in progress on 5 March 2010. (*Author's Collection*)

The new terminal on 13 June 2012. (*Author's Collection*)

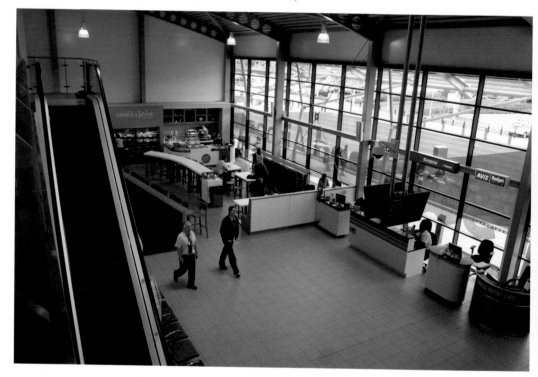

Inside the new terminal on 13 June 2012. (*Author's Collection*)

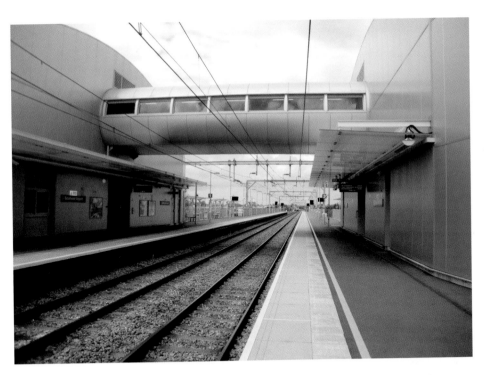

The up and down main lines of the Southend–Liverpool Street line at Southend Airport Station on 14 June 2012. (*Author's Collection*)

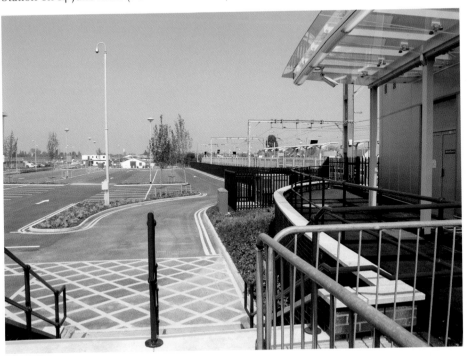

The only entrance and exit to the new station with its large car park. The old Overton building and works containers are in the background on 24 April 2011. (*Author's Collection*)

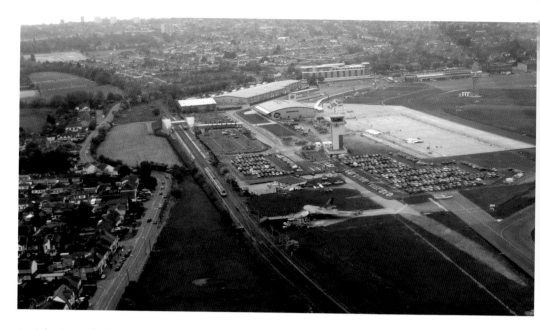

Aerial view of the eastern and southern areas of the London Southend airport and the developments on 19 May 2012. (*Ron Circus*)

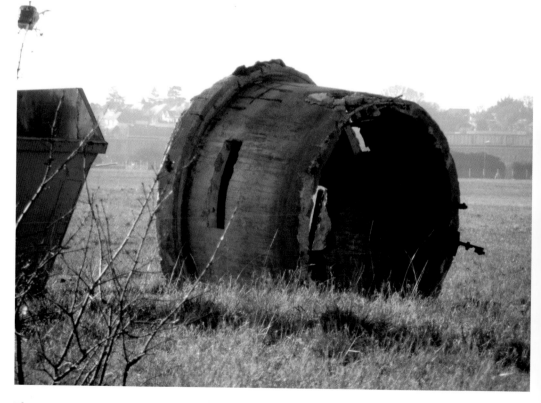

The wartime Pickett-Hamilton Fort, 3 January 2010. It was removed and is now in preservation. The remaining two PH Forts are still buried at Southend. (*Nick Skinner*)

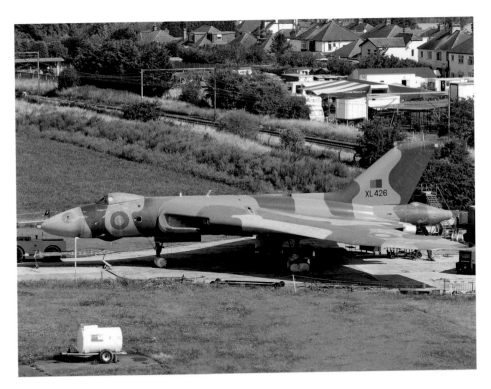

Safe. The Vulcan B2 bomber XL426 (G-VJET) of the Vulcan Restoration Trust at the north end of the eastern perimeter. Across the railway line, the fair was in town when this was photo was taken on 3 September 2011. (*Keith D. Burton*)

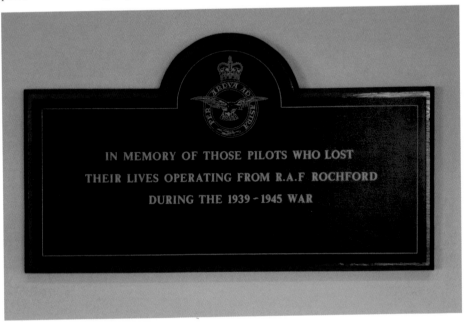

IN MEMORY OF THOSE PILOTS WHO LOST
THEIR LIVES OPERATING FROM R.A.F ROCHFORD
DURING THE 1939 - 1945 WAR

The plaque commemorating the pilots who were stationed at Southend during the Second World War. (*Maurice Smithson*)

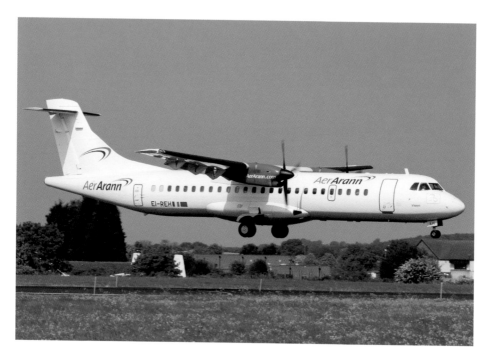

An Aer Arann AT72-201 (EI-REH) arriving from Galway, caught moments from touchdown on Runway 06 in April 2011. (*Calum Glazier*)

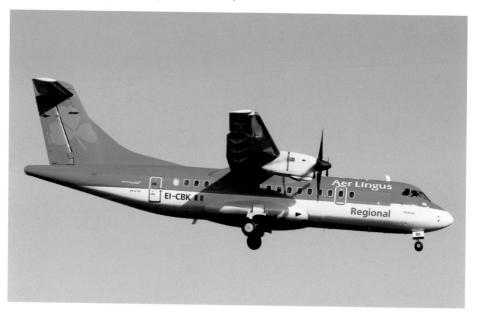

An Aer Lingus Regional AT43 EI-CBK on approach to Southend, arriving from Waterford on a morning Aer Lingus Regional service in April 2012. (*Calum Glazier*)

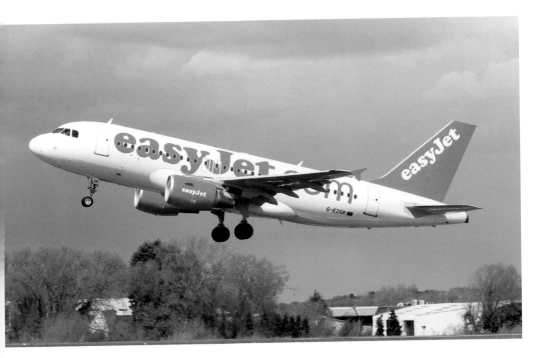

An easyJet A319 (G-EZGR) departing Runway 24 to Belfast in April 2012. (*Calum Glazier*)

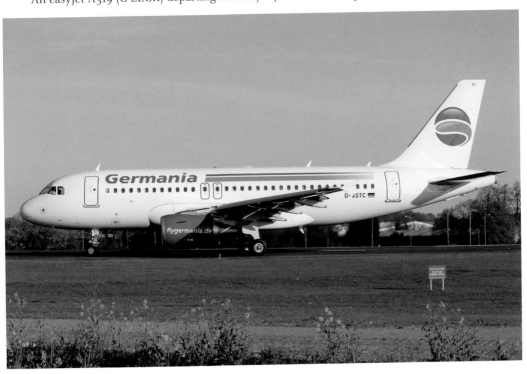

A Germania A319 (D-ASTX) turning around at the end of Runway 06 while operating the weekly charter to Istanbul Sabiha Gocken for employees of the Ford Motor Company in April 2012. (*Calum Glazier*)

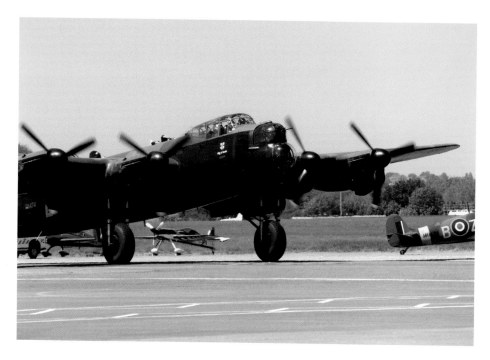

Lancaster PA 474 of the BBMF moves across the apron, ready for its memorial flight with the Spitfire and Hurricane on the second day of the Southend Air Festival on 27 May 2012. (*Author's Collection*)

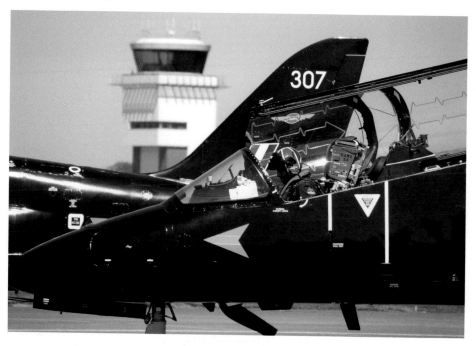

The Black Hawk T1 prepares for take-off to wow the crowds along Southend seafront on the second day of the Southend Air Festival, under the watchful eyes of the new ATC tower on 27 May 2012. This was the trainer for the pilots of the Red Arrows. (*Author's Collection*)

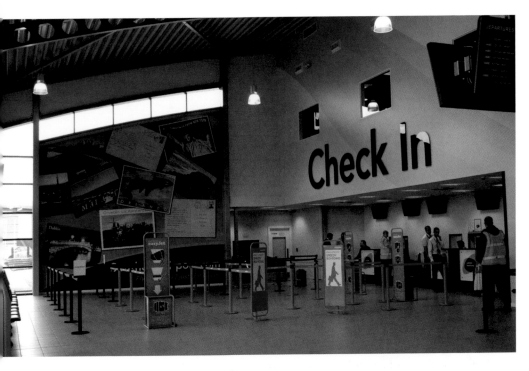

The check-in inside the new terminal on 13 June 2012. (*Author's Collection*)

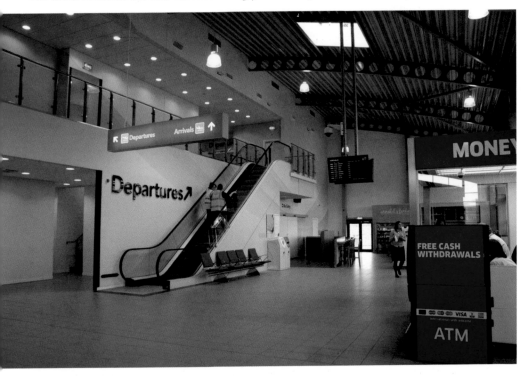

The north end of main hall with the Arnold & Forbes café in the new terminal on 13 June 2012. (*Author's Collection*)

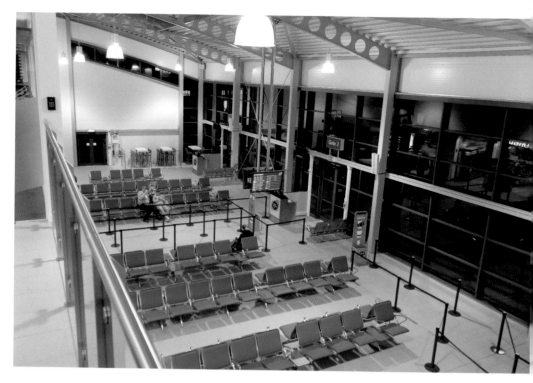

The departure lounge inside the new terminal in April 2012. (*Calum Glazier*)

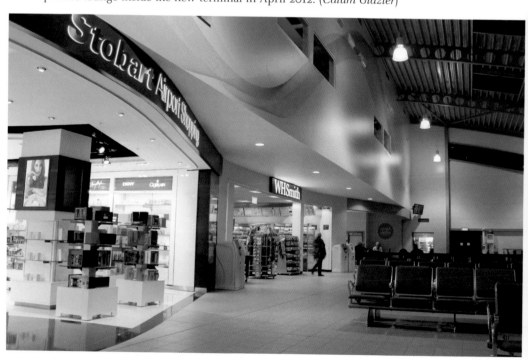

The retail area in the new terminal on the day of the inaugural easyJet flight to Belfast on 2 April 2012. (*Calum Glazier*)

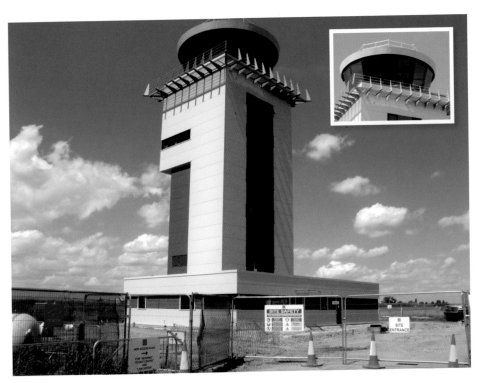

Newly completed, the ATC tower amid the development on 11 July 2010. (*Author's Collection*)

Inset: The control room of the new tower on 11 July 2010. (*Author's Collection*)

The old ATC tower flies the Stobart flag on 5 March 2010. (*Author's Collection*)

Civil aircraft crashes at Southend

On 12 July 1957, a Lockheed Constellation of TWA made an emergency landing with one engine on fire while en route from Frankfurt to Heathrow.

On 28 July 1959, a Vickers 614 Viking 1 (G-AHPH) of East Anglian Flying Services was written off after an emergency landing was made due to the failure of the landing gear. None of the thirty-nine occupants was injured.

On 9 October 1960, a Handley Page Hermes (G-ALDC) of Falcon Airways overran the runway on landing, ending up across the Southend to Liverpool Street railway line. The aircraft was written off but all seventy-six people on board were uninjured.

On 3 May 1967, a Vickers Viscount (G-AVJZ) of Channel Airways was written off when a propeller was feathered on take-off. Two people on the ground were killed.

On 4 May 1968, a Vickers Viscount (G-APPU) of Channel Airways was written off after it overran the runway having landed at too high a speed.

On 3 June 1971, a Douglas DC-3 (PH-MOA) of Moormanair returned for an emergency landing with one engine partially failed, shortly after departure to the Netherlands. It overran on landing, colliding with an earth bank at the end of the runway with two of the thirty-two passengers on board requiring attention for slight injuries.

On 8 October 1974, a Belgian DC6B (OO-VGB) of Delta Air Transport crashed on take-off when the nose wheel collapsed. Passengers and crew were ferried to safety with no casualties.

On 11 January 1988, a Vickers Viscount (G-APIM) of British Air Ferries was damaged beyond economic repair after it was involved in a ground collision with a Fairflight Short 330 (G-BHWT).

Stop Press:

In May 2012 the CAA announced that 66,783 passengers had passed through the terminal, an increase of 1,101.8 per cent on the same time in 2011. In June, 862 air transport flights were made from Southend.

EasyJet also announced that it is to start three flights a week to Geneva from 14 December 2012, and in February 2013 will begin four scheduled flights a week to Venice. This will be the first route to Italy from an Essex terminal.